SELLING PHOTOGRAPHY

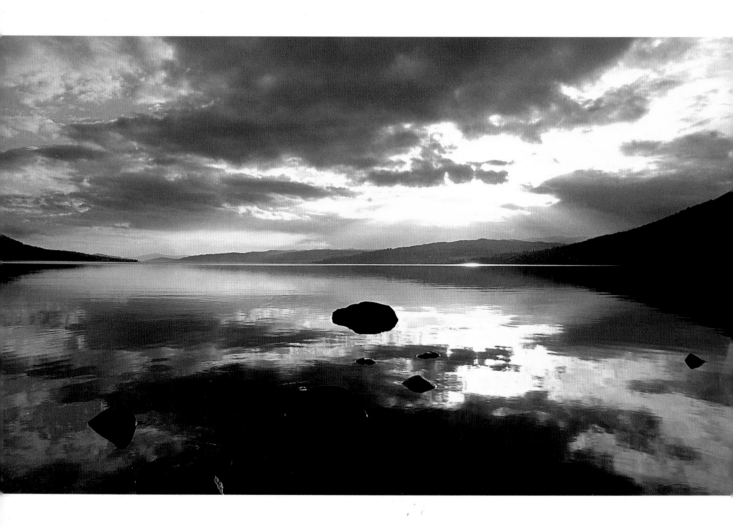

 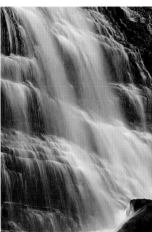 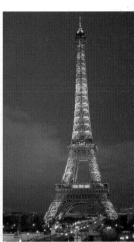

SELLING PHOTOGRAPHY

ROGER ANTROBUS

AMPHOTO BOOKS

An imprint of Watson-Guptill Publications

New York

**I should like to dedicate this book
to my long-suffering wife, Jean,
without whom none of this, or even
that, would have been possible.**

First published in the United States in 2003 by

Amphoto Books

an imprint of Watson-Guptill Publications

a division of VNU Business Media, Inc.

770 Broadway, New York, New York 10003

www.watsonguptill.com

First published in Great Britain in 2003 by

Collins & Brown

64 Brewery Road

London N7 9NT

A member of **Chrysalis** Books plc

Library of Congress Control Number: 2002110139

ISBN: 0-8174-5839-5

Color reproduction by Classic Scan Pte Limited, Singapore
Printed by Imago, Singapore

1 2 3 4 5 6/07 06 05 04 03 02

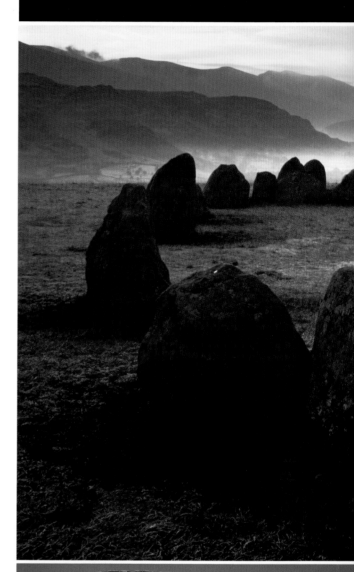

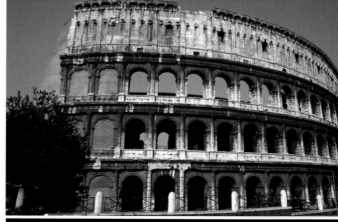

Contents

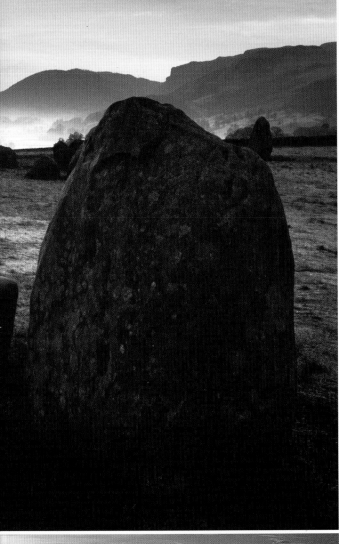

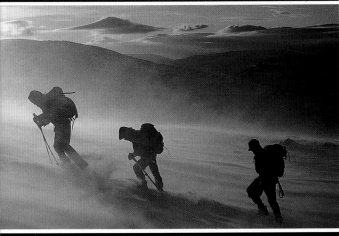

Why stock photography?

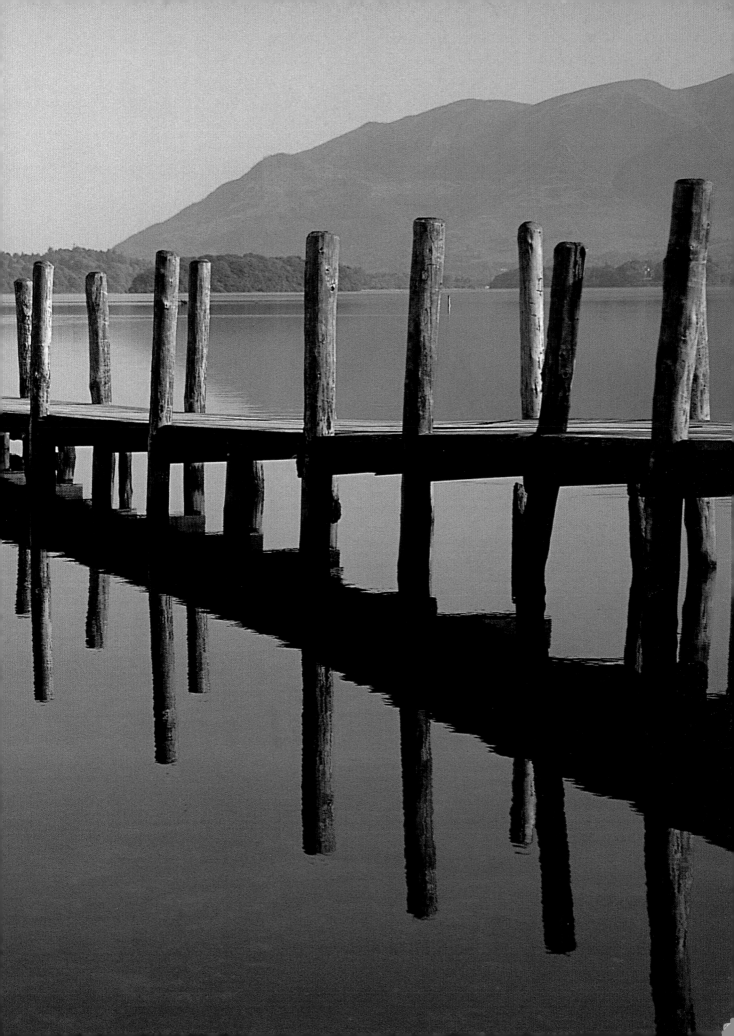

Stock photography

The evidence of the enormous need for photographs is overwhelming. At any news-stand, bookstore, or travel agency you will be surrounded by images. At home, on packaging, calendars, mail-order catalogs, and CD boxes, you will find hundreds more photographs.

All these images have to be provided by someone, and, surprisingly, only a very small percentage of them are specially commissioned by a client for a specific purpose. The vast majority come from commercial photo libraries, agencies that store thousands or millions of pictures, ready for every occasion and every requirement.

The success of libraries stems from the fact that it is so much cheaper to buy the use of a library photograph of, for example, the Eiffel Tower in Paris, France, than to commission a photographer to fly over there and take the shot specifically.

In many cases it might even be impossible to get the picture that is required except through a library; for instance, currently it might be high summer, and the client wants a picture now of the Eiffel Tower in snow. A library can offer a client a whole array of images of a subject taken in different seasons, at all times of the day, with a variety of lighting conditions, in various weather conditions, with and without people, and so on. This degree of variety is impossible to achieve on a commissioned shoot.

Clients are usually completely unconcerned with the identity of the photographer. They really are only interested in the image, and whether it is right for their purpose. Naturally, there are some cases where a particular photographer's style is required, such as that of Sebastião Salgado, but these are rare.

So, whether the photographer is a professional or an amateur has little bearing on the success of a sale. For the amateur, stock photography can be a really enjoyable pastime, but can also provide you with a very healthy income.

Turning a hobby into profit

Most hobbies cost money, and photography is no exception—in fact, it is really quite expensive. Even when you think you have all the equipment you need, there are always new things to invest your money in, such as computers and digital scanners.

For an enthusiast, the film and processing costs can easily amount to hundreds of dollars or pounds every year. However, with a little effort it is quite possible to earn enough to cover these costs each year. All you need to do is study the stock image market and then adapt your photographic shooting habits to meet its demands.

In fact, if the task is taken seriously, it is quite possible to make many thousands each year. Imagine: just by considering your picture-taking a bit more seriously, you could easily afford to pay to visit the exotic locations you dream of photographing, and with the right accountant, these trips could then become tax-deductible, because they would provide more shots for you to sell.

The specific demands of the stock image market mean that the direction of your photography may have to change to meet its requirements; and certainly the way you look at pictures must change to include the style or mode currently demanded.

A major benefit of deciding to get into stock photography is that it immediately gives your hobby a purpose and direction. No more will you hear yourself say, "I don't know why I take all these pictures, I never do anything with them," and it will become that much easier to find subjects that you want to shoot. As a stock photographer, you now have a goal where judgment is not made by an arbitrary band of club competition judges, who are frequently quite out of touch with the real world, but by picture buyers who judge photographs by putting their money where their mouths are!

Right: Taken from the Palais de Chaillot with eye-catching, early evening color, this shot has sold 16 times so far, including front covers of three travel catalogs. Shot with medium format, the Eiffel Tower has been composed off-center to allow the buyer either to crop to a vertical format, leave as is, or put text on the left. I have made over $2,900 (£2,000) from this image alone.

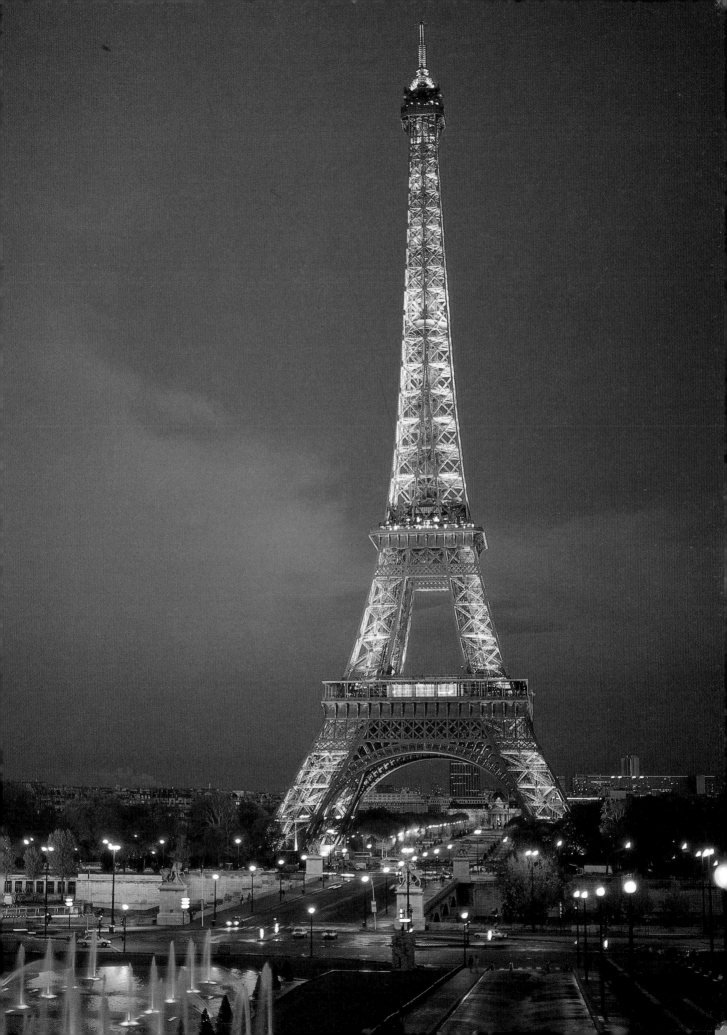

Earn money on a family vacation

Most photographers find that it is not really practical to combine taking serious photographs with a family vacation, because of the thought and consideration that must be given to the other people involved. Photography can be a very time-consuming task, which is difficult to tolerate for a non-photographer. They rarely have the patience to wait for the right light, wait for the clouds, or wait for people to move. In my early days of stock photography, I traveled alone or with other like-minded photographers.

In later years I have found that it is quite possible to combine taking serious photographs with the family vacation, simply by adjusting my method of working. The best light for most location work occurs before breakfast and in the early evening. So, I get up early, leaving my companion still slumbering. I get all the best light for my images, and return for a leisurely late breakfast. I find that my wife enjoys the time to herself, at her own pace, getting ready for the day. The holiday part of the day can then begin. You have already gotten some good images in the can, so you can relax and enjoy the sightseeing, shopping, or whatever—and, of course, take the occasional additional picture.

This middle portion of the day, when the light is less good, can be used most productively for reconnaissance to establish subject matter, locations, and viewpoints to return to another time. Come early evening my wife is invariably ready for a refreshing bath—just the time to go back to take more pictures in the improving light. My wife and I frequently travel with another couple, and this arrangement works very well for all concerned. Your partner and family might well be happy with a similar arrangement—especially when your royalties start coming in, and they discover that you can take more frequent vacations.

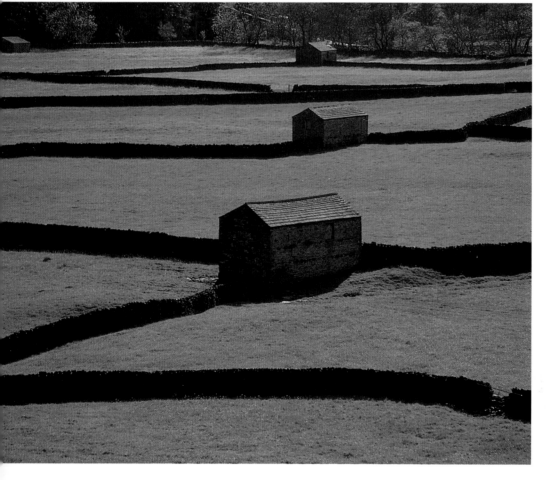

Right: A view from the eastern shore of Loch Rannoch in Scotland, looking west toward Glen Coe. I waited ages for these conditions, then composed using the strong, diagonal cloud shapes to increase the drama. The most exciting sale of this picture was for an exhibition stand.

Left: This typical English Yorkshire Dales scene was taken from beside the road while on a journey to see friends—not every salable shot has to be taken on a proper "photographic shoot." The drystone walls provide very good ingredients to achieve a strong composition.

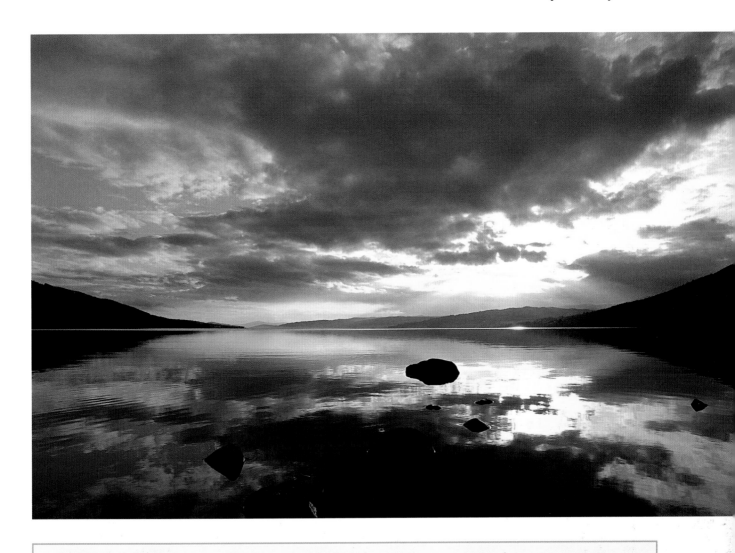

Avoiding the tripod

The tripod is probably the most time-consuming element to taking a photograph, and it is this waiting around for the tripod that I have found is most frustrating and boring for my non-photographic companions. When the light is low before breakfast and early evening, it is likely that you will want to use a tripod, but during the day it can be

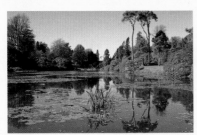

Above: Taken on a family walk around the gardens of Sheffield Park in Sussex, England.

avoided, especially if you use image-stabilizing lenses, such as those produced by Canon and Nikon for their 35mm SLRs.

Also be aware that as soon as you put up a tripod in a city you may be liable to pay a license fee to the local authority, and if you do not get this license beforehand, it is quite likely you will have to pay an on-the-spot-fine. Similarly, in many other areas you need to get permission to use a tripod, and quite often pay a fee for the privilege; this is standard procedure in many cathedrals, most stately homes, and in a number of historic properties.

If you tell the licensing authority that you are a professional photographer, the fees can be a great deal higher. This might be fair and reasonable for a photographer shooting for a specific commission, knowing what he or she will

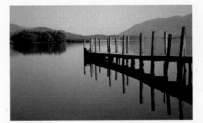

Above: Captured last year from the Lodore end of Derwent Water, this quiet and restful shot could be used for the front cover of a CD of mood music. Plenty of room for text has been left in this English Lake District scene.

earn from that shoot, or who is able to charge the fee to expenses. But it is quite unreasonable for a stock photographer, who has no idea whether the image will ever sell.

Stock photography provides a pension

The income from stock photography takes quite some time to build up. In my own experience, it has taken about two or three years of frequent submissions to a particular library before the income became regular and to some extent dependable. Today I have over 5,000 pictures divided between four different libraries.

If the image is what the buyer wants, it does not matter how old it is. I still have a number of pictures selling that I took during the mid-1980s. This is the fundamental financial strength of stock photography—once an image is in the library, it can sell and sell with no additional work

It improves your sales to "refresh" images, retaking them in the current style and in the current setting, so bringing the image up-to-date and therefore making it more desirable. When I started in stock

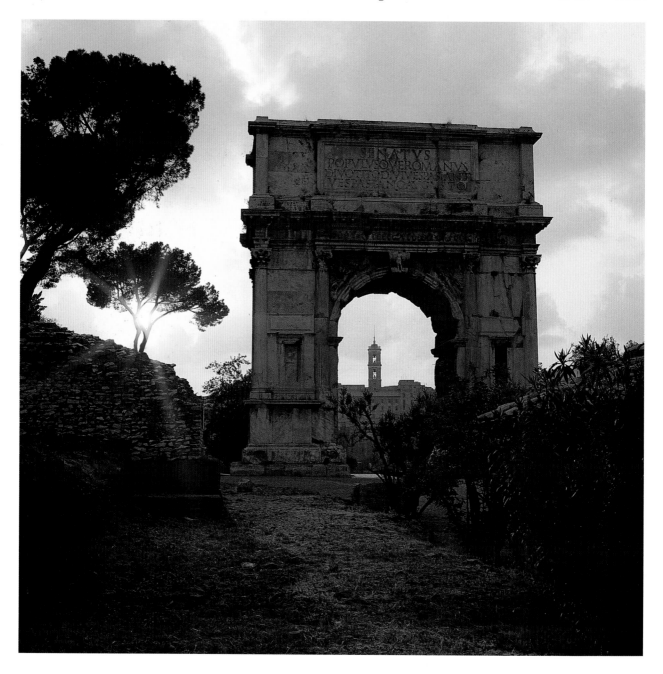

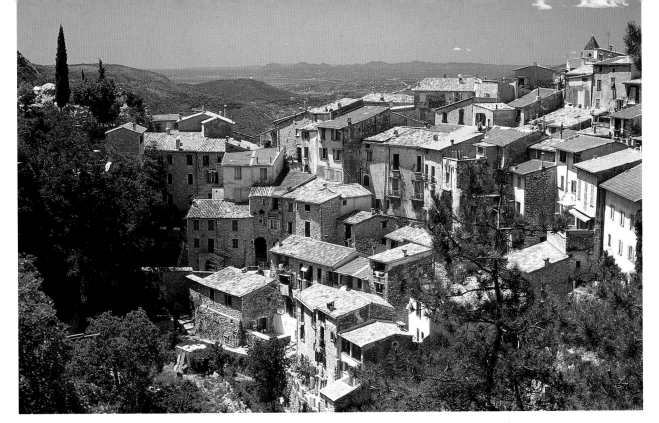

Above: This view of Peille—a hill town in the French Riviera behind Nice—was found with the help of a guidebook. It has sold 21 times over 10 years, and is still selling well to illustrate this attractive and popular hiking and tourist area.

Left: The Arch of Titus in the Forum, Rome, Italy—a medium-format shot of a typical Roman scene with romantic lighting. This has sold well for reproduction in "city break" travel catalogs over a period of 15 years.

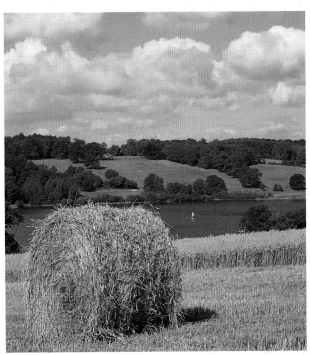

photography about 20 years ago, I used to have about 300 images accepted by each library each year. Nowadays, I have about 150 accepted a year—but still earn more, because I have learned what the markets require and am therefore more selective.

Once the image is in the library or on-line it will keep selling. The income keeps on coming even if you retire and take no more pictures, thus providing a pension for your old age.

Above: This shot of Ardingly Reservoir in Sussex, England, has a very summery feel. I spent several days at this farm in 1987, photographing all the harvesting activities. Shot in medium format, the picture has sold nine times including once as the front page of a calendar.

Additional revenue stream for professionals

Few professionals use the stock image market as well as they could. They are sent on assignments all over the country and world, but invariably fail to make the most of the locations to which they have been sent. Adding on an extra day for their own work would add little to the overall cost of the assignment. Furthermore, most photographic businesses could make use of an additional revenue stream from images already languishing in filing cabinets, accumulating dust rather than cash.

On certain assignments, the client might release the images taken that are surplus to requirements, so the photographer can then capitalize on their value.

Use a library—or sell direct?

There are plenty of ways to sell your photographs, other than using a library. Selling directly to the end user appears to be an excellent way to maximize your profit, because you don't have to pay half the photograph's earnings to a library. In addition, you are completely in control of the whole process, so you are not reliant on others doing their jobs efficiently.

Selling directly via the internet is one possibility. You can set up your own website, or even ride on the back of an established portal. Here you can display whichever images you wish to promote. You are your own editor, unlike being with agencies, where they select which of your images they take and which ones they put on show. Furthermore, you can charge what you want (within reason), and you keep all of the revenue. But how do you get the buyers to look at your site? How do you let them know your super images even exist?

In selling direct, you are entirely on your own. The images have to be selected by you and sent off to a prospective buyer. Unless you have made copies you have to send the original, and while these originals are with the buyers you cannot use them for any other purpose. If it is the original you have sent, you risk losing it, and you have to wait until the buyer chooses to use it or not—in any event, they are likely to keep it for months rather than weeks. You have to keep excellent records so you know who has what, and you can follow up on their returns. This may sound easy, but in my experience, it's a most time-consuming and frustrating business.

Below: This colorful image of Villefranche in the south of France has been a steady earner for a number of years, selling 40 times to date.

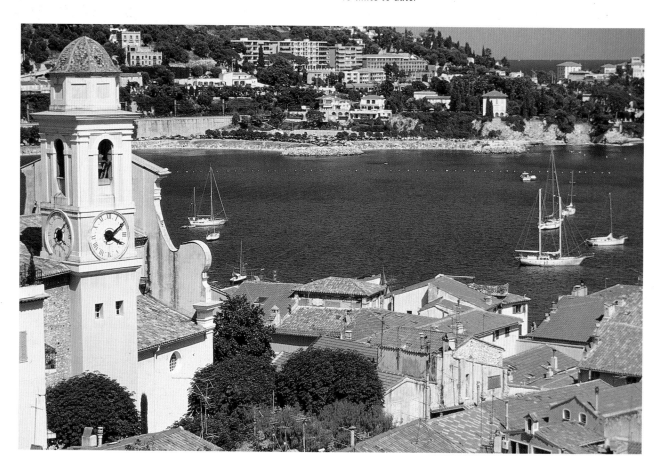

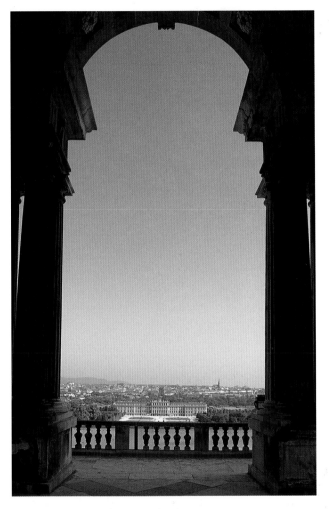

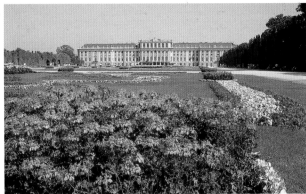

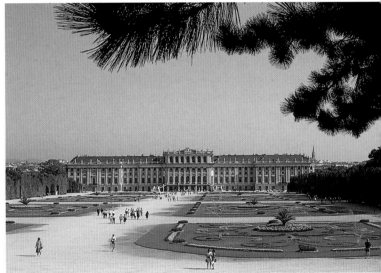

Above: Three entirely different views of Schönbrunn Palace, selected from the two rolls I shot of this subject during a trip to Vienna, Austria. It costs time and money to travel, so it's worth getting as many different images of a place as possible.

If you do go down this route, you must supply the images under proper terms of business, where if the buyers lose the transparency you get some reasonable compensation—in 2002 this would be somewhere between $150 and $300 (£100–£200).

Worst of all, you have to chase those people who seem to want to forget to pay you. Again, this sounds easy, but it is actually difficult and embarrassing. You don't want to get too cross with clients who delay and delay payment if they are regular buyers, because this may color their views about you, and, in any case, the accountant who issues your check is undoubtedly not the same person to whom you sent the pictures.

Probably the one area where a good agency scores is in its ability to get your image in front of multiple buyers in multiple markets simultaneously. An international agency may duplicate your transparency, say 64 times, and give two copies to each of its 32 offices worldwide. The library may put the image on its website, where it can be seen by all interested parties. The big image buyers know which sites offer them the best choice for a particular type of image, and return repeatedly, rather than scouring the entire internet—because we all know just how time-consuming searching for things blindly on the web can be. It is very difficult for an individual to compete successfully in this way, because he or she will never have enough images of the required variety to be a match for the large international agencies.

Libraries look after all of the administration and marketing; they provide the buyer with a selection of images, retrieve the transparencies, bill the buyer for the ones used, pay the photographer, and manage any bad debts or payers. It should be remembered that

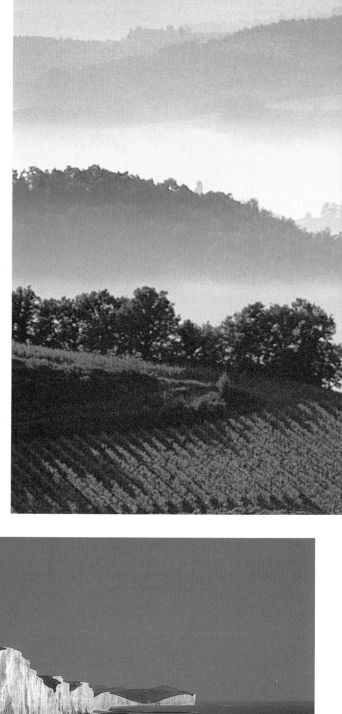

for a one-person operation (as many freelance photographers are) time spent on administration is time that cannot be spent taking photographs.

Using agencies, you also receive guidance from them regarding what the marketplace is looking for, trends in image style, and a multitude of other useful tips that can help to steer the whole project in a profitable direction.

But most important is that the libraries do their own marketing, which naturally includes promoting your images. This ensures that prospective buyers worldwide are aware of their existence and your fields of expertise. This is an enormously expensive operation; it used to be done principally by producing thick catalogs of images in glorious color that were then distributed to potential clients. The cost of choosing the images and the production is significant enough, but the cost of printing is enormous.

These days far fewer catalogs are being produced, because the internet can be used to show an entire collection of pictures. A website can be used to sell and transmit digital images directly over the internet connection, and you can search for the images you want more exhaustively by using key words.

For a small library to produce full-color catalogs in sufficient quantities to send to all prospective buyers would be an enormous drain on resources, let alone being impractical. For the sole trader, it would be financial suicide.

Right: These chalk cliffs in the Seven Sisters, in Sussex, England, are very similar-looking to the symbolic white cliffs of Dover. These are actually over 50 miles (80 km) away, but despite accurate captions, images like this are frequently used to illustrate their cousins in Dover, Kent.

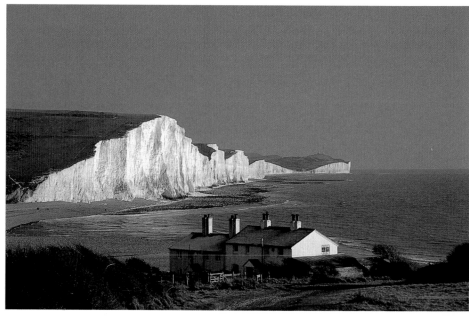

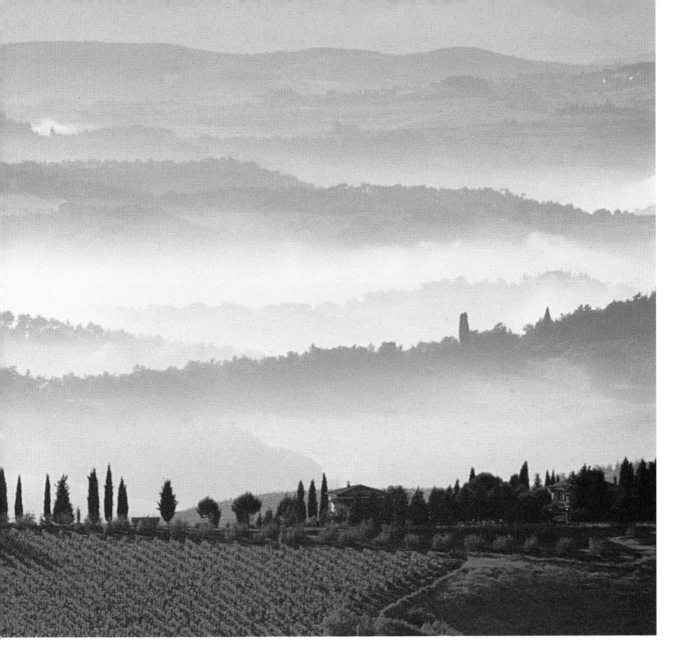

Running a website

Setting up your own website has the same advantages and disadvantages as running your own library, but the marketing is even more important.

How does the market know your website exists, and why should anyone bother to look at it? OK, so they might manage to find you, but then they want an image of the Schönbrunn Palace in Vienna in the mist, but you only have two pictures of it and neither has any mist. The buyer then goes to a big agency and finds a choice of over 30 images, several with mist. For the next request, why will he or she bother to try your site when it offered such a small choice? A small library stands the best chance of success if it has a really specialized niche market, that is not covered by the big international agencies.

Some enlightened photographers have gotten together and share websites. This gives them more financial muscle, because the cost of advertising is spread among all the members, and increases the pool of images to provide greater variety to the buyer.

It is quite feasible to create your own website and sell your images on-line, and it is also possible to create your own CDs and market them to picture buyers. Both of these routes require a book in themselves, and cannot be covered here in sufficient depth.

Above: Position in my bestseller chart: #1. Number of sales: 93. Highest single sale: $1,419 (£972). Number of years since first sale: 8. My total income to date: $17,292 (£11,844). My most successful photograph to date has sold for every purpose imaginable. Its success is simply that it is an atmospheric and generic shot of Tuscany, Italy. Taken near San Gimignano early in the morning, it would have been a very ordinary image if it hadn't been for the rising mist. And it is still selling really well!

What equipment?

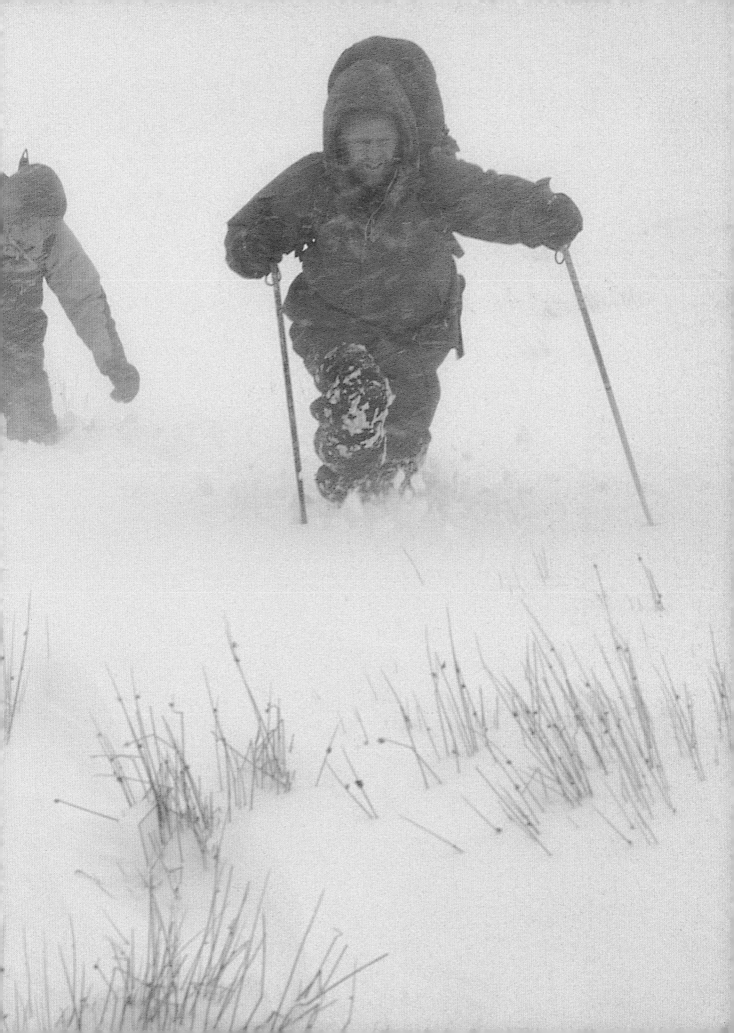

Formats

A few years ago it was the rule that libraries generally wanted medium-format transparencies or larger, especially for certain markets such as calendars. In recent years, film quality has improved considerably, making the use of 35mm much more widespread. There are still certain markets that demand medium format—the North American National Parks, for example, have been photographed extensively in medium and large format, so 35mm shots will always struggle to compete in this area.

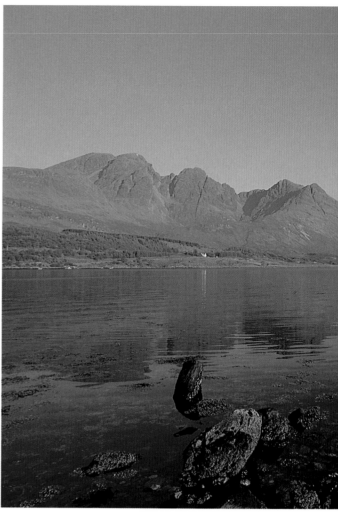

Above: A typical New England scene, shot while looking for a lunch stop with my family—just one of many salable shots that I have taken with a compact camera.

Right: Shot from the "Landing Stages" in Keswick, England, on a Yashica T4 compact camera that cost only $138 (£95), this scene is so popular there are tripod holes in the ground!

There is no doubt that the reproduction quality from medium and large formats easily surpasses that of 35mm. However, the majority of images from stock libraries are published in a smaller size than A4, and larger film formats will not show much advantage until printed this size or larger. This therefore provides a significant market for 35mm film, so long as the shots are very fine-grained, exceedingly sharp, and fully color-saturated. Some libraries take top-quality 35mm images and dupe them up to 6x9cm; the client then sees a larger, easier-to-view image and is more likely to buy.

A full kit of medium-format equipment is heavy and cumbersome, and almost invariably demands the use of a heavy tripod. Almost everything about 35mm is smaller and lighter—even a set of filters is probably lighter because the front elements are usually

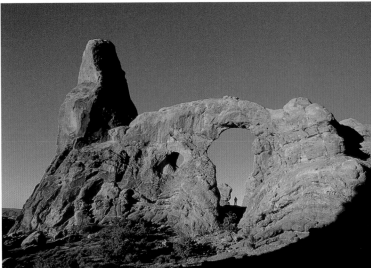

Left: The red hills shot from Torrin across Loch Slapin on the Scottish Isle of Skye. This place has a special romance and images of it are always in demand. All my pictures are now shot on 35mm.

Above: The lighting and the cowboy in Turret Arch, Arches National Park, Utah, give this image appeal but, being 35mm, it is up against stiff opposition from medium- and large-format shots.

smaller. The tripod necessary for 35mm can also be a little lighter and less formidable.

In post-production the viewing and checking of the transparencies for quality and sharpness is very much easier on medium and large format. For 35mm images I have a quality projector and screen permanently set up, and always project every image that I am going to submit, to check all aspects. With a quality lens, a screen adjusted to be absolutely vertical, and with the projector correctly centered, you can really discover if the image is perfect. With medium format, a good 4x loupe on the lightbox is perfectly adequate to establish the quality of the image, while using an 8x will suffice to check critically for sharpness.

The make and type of camera is quite unimportant, provided that the lens and film are of the highest quality, and the film is kept flat in the film gate. I have successfully sold many images shot with compact cameras (such as a Minox 35GT and a Yashica T4).

My stock of images with libraries has been taken on a range of equipment including Fuji 6x9, Hasselblad, Mamiya rangefinder, Nikon SLRs, and Leicas. Nowadays, I mostly use Canon EOS cameras. However, picture buyers do not care at all what equipment was used—they are only interested in the picture's suitability and technical quality.

Using two camera bodies

I use two camera bodies, and alternate them daily to minimize risk of failure. For example, it is just too easy for a hair to get into the film gate and not be visible when changing film. I have heard many stories of how the camera appeared to be working just fine, but all the images were ruined.

It might be wise to check all working components each time the film is changed, but who can remember to do this when exciting images are waiting to be captured?

If the camera body is changed each night, then only every other day's worth of shots is risked.

Digital and film cameras

At the time of writing, digital cameras have not yet developed to a level where they can be considered to equal or surpass film. The one exception is the medium-format attachment backs, which are only really suited for studio use. Digital SLRs are perfectly satisfactory for shots where the output is for the press, and are increasingly used by reportage and sports photographers. But the stock market does not know how big the image buyer will want to print a particular image. Many libraries will now accept pictures in digital form, but demand file sizes in excess of 30MB, and usually in excess of 50MB. Most digital SLRs produce a file that is significantly smaller than this. It is possible to increase the file size using software, but the quality may still not be quite good enough. The quality of the light-sensitive chip (CCD or CMOS) and file output continue to improve at an astonishing pace, however, and it won't be long before digital SLRs are able to provide a serious alternative to 35mm film for the stock photographer.

The small digital file size is not the only drawback of digital SLR cameras. Most are presently unable to capture full-frame 35mm images, therefore making old lenses longer than they really are. Typically, a digital SLR may have a ratio between the light-sensitive chip and the transparency frame of 1.6, meaning that a 50mm lens will effectively become an 80mm. This is useful for those who do predominantly telephoto work, where the standard 200mm lens is now a 320mm, but it is a real handicap for wide-angle situations, because the 20mm lens is now only a 32mm.

For the moment, therefore, we are left with transparency film, which at the present time can store much more data than can be done digitally. But slide film does have inherent disadvantages:
- It must be stored in a refrigerator.
- It must be loaded into the camera without getting dust or grit in.
- After being taken out of the camera, it must be refrigerated again before processing.
- It must be chemically processed, without getting contaminated or scratched.
- It must then be selected and sent to the library, or scanned.

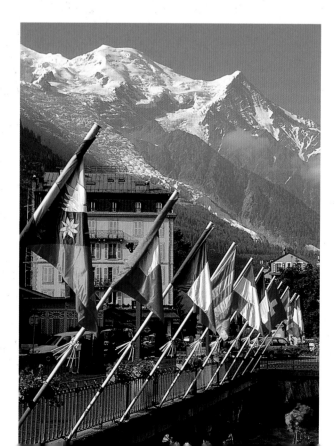

Left: Mont Blanc seen from Chamonix in the French Alps. It is a very popular resort for both summer hiking and for winter sports, so there is a healthy demand for images of this area.

Right: Position in my bestseller chart: #2. Number of sales: 94. Highest single sale: $2,640 (£1,808). Number of years since first sale: 12. My total income to date: $16,127 (£11,046). Shot at a "country fair" just a few miles from my home in Sussex, England, this image of an owl has been used principally as an eye-catcher to attract attention, and has even been used on the front page of a newspaper. Its most lucrative sale was for a product launch in the electronics industry.

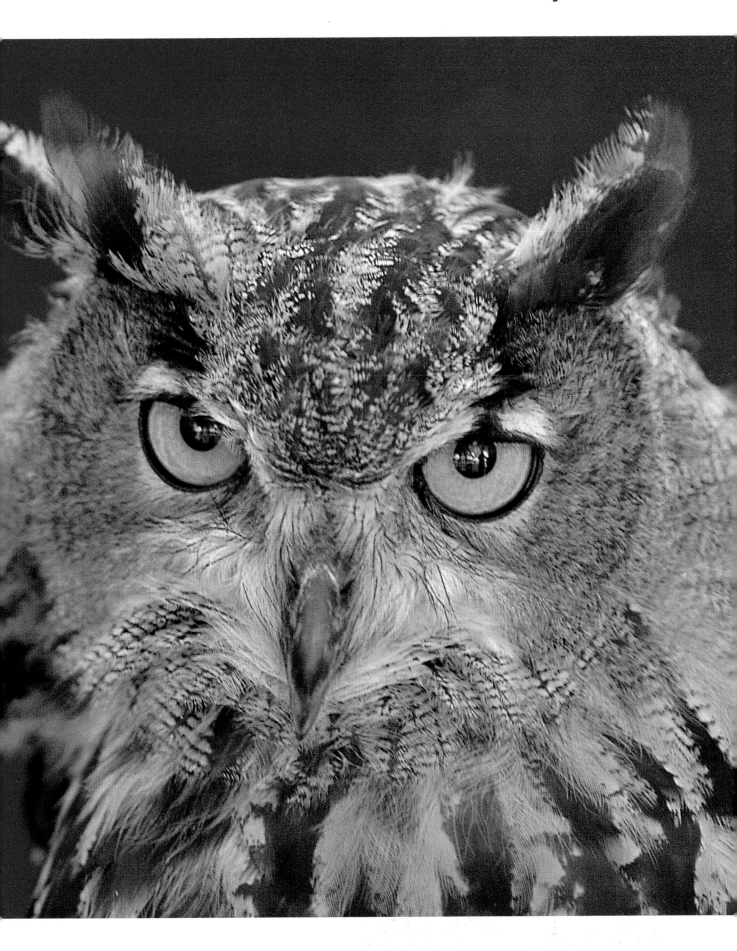

Films

Some years ago Kodachrome was the *de facto* standard for stock photography. But the difficulty of processing this film, and the constant refinement of E6 films, which are easier to process, has meant that Kodachrome is no longer king. Fuji Velvia is now the favorite film for most stock photographers, thanks to its fine grain, superb color saturation, and incredible sharpness.

However, while this ISO 50 slide film is fine for subjects where shutter speeds can be slow, it is not suitable for moving subjects such as wildlife and sports. When faster shutter speeds are needed, a faster film such as Fuji's Provia F is preferable; this gives exceptionally fine grain, excellent sharpness, and good saturation at ISO 400 and ISO 100 film speeds.

I know of no agency or library that accepts negatives—instead, they all require transparencies or digital files. However, there is no reason why you

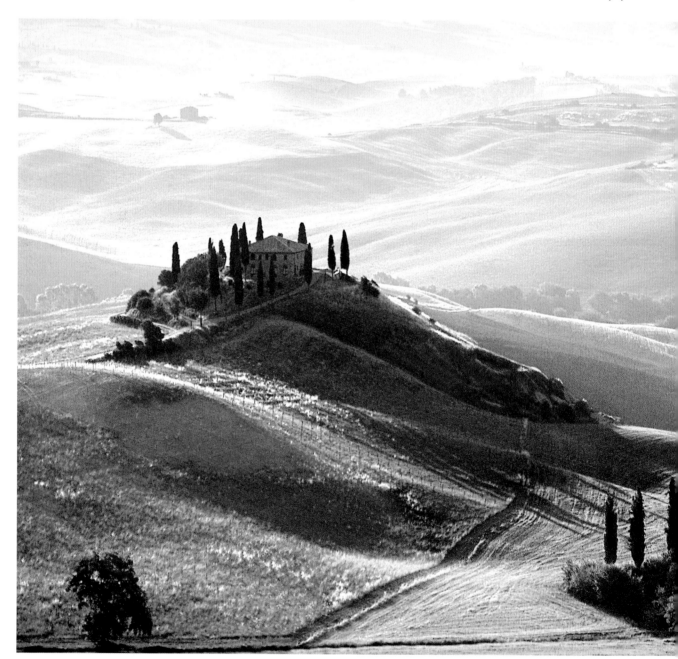

should not shoot print film and then scan the negative to produce a digital file. Negative film has a greater exposure latitude than transparency—when using Fuji Velvia, for example, the exposure must be correct to ⅓ of a stop, but negative film can be satisfactorily scanned, even if it is two stops adrift.

The travel photographer who is going to be working for a prolonged period in a hot country away from a source of film, and therefore has to take all that he or she needs, may not want to take Velvia because it is a "professional" film and starts to deteriorate as soon as it is taken out of the refrigerator. If a fridge is not available, then it might be best to use "amateur" film, such as Fuji Sensia, which holds its quality very much more steadily in adverse conditions. While Sensia is not as fine-grained, as sharp, or as saturated as Velvia, it is still very good film.

All the pictures in this book were shot either with Velvia, or, in the case of those taken before 1990, using Fujichrome RFP (50 ASA).

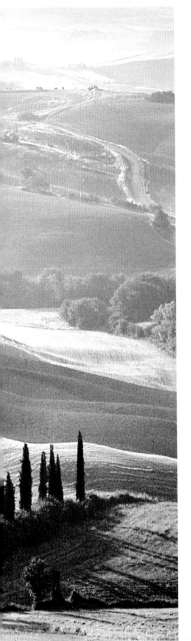

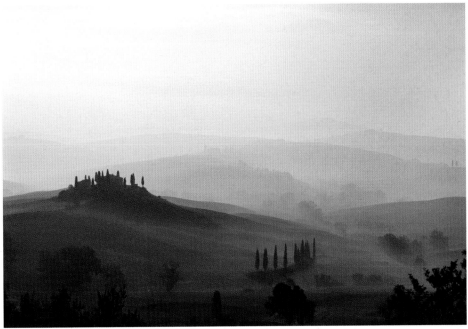

Left and above: Both these shots of San Quirico, near Pienza, Tuscany, Italy, were taken using Fuji Velvia, but two years apart. The sepia toning was added using Adobe Photoshop. These typical Tuscan scenes are just by the roadside, but you do have to get up before breakfast—after 8 a.m. the atmosphere has gone. The color version earned me "Illustrative Photographer of the Year 1998" from the British Institute of Professional Photography, and the sepia version did the same in 2000.

Black and white or color?

The choice between color and black-and-white film is much easier with medium-format cameras with exchangeable backs, because film can be switched on demand. With fixed-back cameras, and especially with 35mm, where the film length is so long, it is more difficult. The obvious solution is to carry two bodies, one loaded with color and the other with monochrome film, but this adds to the total weight of your equipment.

For those who are into digital imaging, converting a color image into black and white is very straightforward. I carry only one camera body, and when I see a shot that would possibly be better in black and white I compose accordingly, and convert it on the computer later using Photoshop. The image can then be used in monochrome or color, giving me the best of both worlds.

Zoom lenses

Some years ago it was quite apparent that zoom lenses were not as good optically as prime lenses, but with the advent of computer-designed lenses much of this disadvantage has been overcome. I changed over from prime lenses to an all-zoom set-up back in 1995, and have been very satisfied with the results.

For ultra-critical work there can still be a difference, but for the majority of uses zooms are now perfectly acceptable for stock photography. The advantage of having a range of, say, 28–135mm on the camera as a "standard" lens is enormous, because you are always ready with the right focal length, no matter what crops up. Just as importantly, there is no time wasted in changing lenses, and far less risk of hairs or dirt entering the camera. The weight advantage is also significant—the weight of a set of 28mm, 35mm, 50mm, 90mm, and 135mm prime lenses will be far in excess of a single zoom.

However, many zooms have some quirks that you need to be aware of, so that you can adjust your picture-taking accordingly. By their very nature they are a compromise of optical design, and what is right for the wide-angle end is not necessarily right for the telephoto end; more often than not, it is at the zoom's extremities where there are most likely to be short-comings, some of which can be overcome. For example, with a zoom of 28–135mm, at the 28mm focal length there could well be minor vignetting of the corners when using the largest aperture. Alternatively, with a 100–300mm it is quite likely that there will be a softening of the image edges at the 300mm end. This will not be detrimental to a

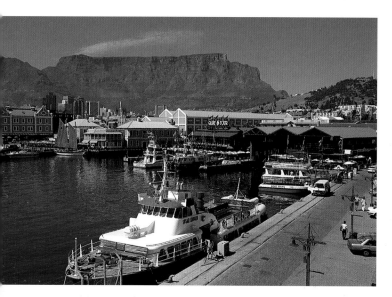

Above and right: The two lenses that I usually carry with me nowadays are both zooms— a 28–135mm, and a 100–400mm for my 35mm SLR. The four shots here show the extremes of focal length available from each—28mm, 135mm, 100mm, 400mm. The two on this page are of Cape Town Harbour, South Africa.

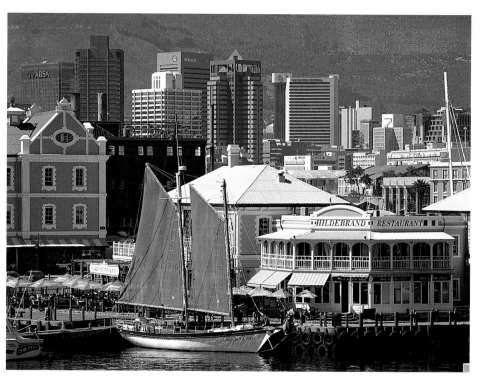

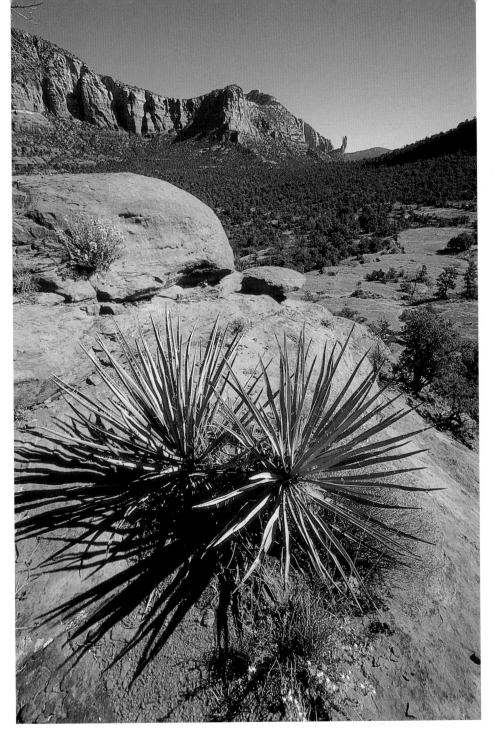

Left: Sedona National Park, Arizona—great depth of field, hand-held at a 28mm focal length with a 28–135mm image-stabilizing zoom lens.

Below: These lion cubs In Masai Mara National Park, Kenya, were shot using a 300mm image-stabilizing lens, hand-held, with Fuji Velvia. The image was taken on a camping safari, and I was fortunate to have the use of a jeep with a refrigerated box in which to keep my film.

shot of a tiger, say, where the animal is sharp and the background grass is out of focus, but you need to bear it in mind. The important thing is to test your lenses to know their characteristics, so as to use their strengths and minimize their weaknesses.

Prime lenses are smaller and lighter when attached to the camera, usually making them easier to hand-hold, and the depth-of-field measurements can be carried out with reasonable accuracy, whereas most modern zooms are bigger and heavier than prime lenses, and it is almost impossible to accurately set the depth of field or hyperfocal distance (see p. 86).

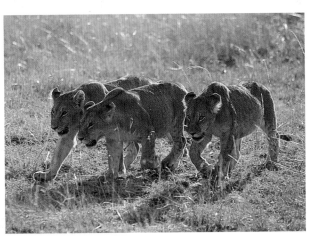

Image stabilization

The tripod is a most cumbersome, but essential, piece of photographic equipment. There are situations where a photograph just cannot be taken without it, such as night shots and long exposures. To ensure maximum stability, you must have a stout tripod, but these are inevitably heavy, although recently introduced carbon-fiber models are really excellent, showing a 30% weight reduction and greater rigidity over conventional designs.

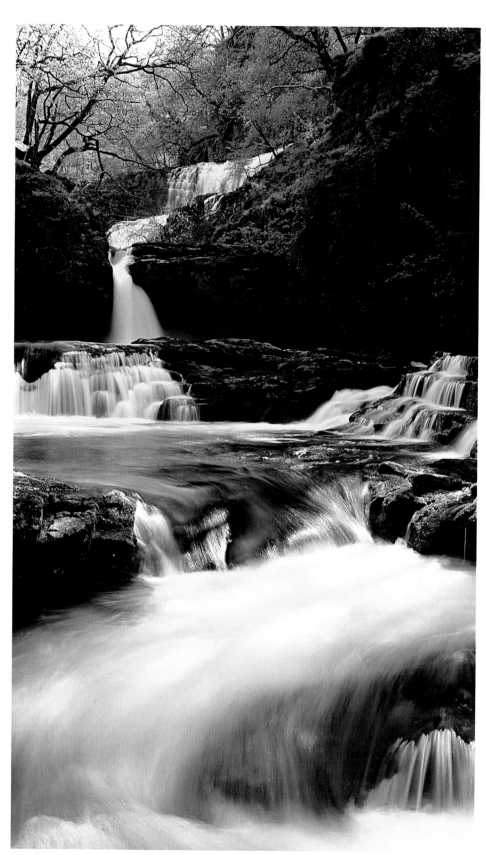

Right: The middle Clungwyn waterfall, Brecon Beacons, Wales, shot with the 28mm setting of my 28–135mm image-stabilizing zoom, hand-held at ¼sec.

New technology, however, means that you can now use slow shutter speeds and get sharp pictures without using a tripod. Image-stabilizing lenses have revolutionized the way to take pictures. These lenses are designed to detect and counteract camera shake, allowing you to get blur-free, hand-held pictures at much slower shutter speeds than normal.

The secret is a vari-angle prism in the lens. This is made of two sheets of glass filled with a high-refractive fluid surrounded by bellows. By squeezing the side of this unit, the light can be bent to counter-act the involuntary movement, which is detected by two sensors in the lens. All this happens without any delay to the normal picture-taking process.

The manufacturers cautiously claim that the benefit is a two-stop improvement, allowing you to use a $^1/_{30}$sec exposure safely, when previously you might have had to use $^1/_{125}$sec. My experience is very much more exciting—I can confidently hand-hold my Canon 100–400mm IS zoom at the 400mm focal length end at $^1/_{60}$sec, or $^1/_{30}$sec if I balance the lens on the crook of my arm, making a three- or four-stop improvement.

With my 28–135mm IS zoom lens I can hand-hold at the 28mm focal length down to a shutter speed of $^1/_8$sec, and if there is a convenient tree or rock, down to $^1/_4$sec. This is a four- or five-stop improvement.

Using the 400mm at $^1/_{60}$ sec allows me to shoot in low light, or use smaller apertures to increase depth of field, although the slower shutter speeds will give problems with subject movement. With the 28mm at $^1/_8$sec I can not only use the smallest apertures to achieve significant depth of field, I can also use a very slow shutter speed that makes it possible to get those milky effects with waterfalls, and other blurred effects, without a tripod.

After the early-morning and before the evening low-light shots, I use my two image-stabilizing lenses instead of a tripod. These lenses have given me a great deal of freedom, because I can leave the tripod behind.

Left: Image-stabilizing lenses allow you to take sharp pictures without the need for a tripod.

Above: This image of a cardinal's badge in a church window in Rome, Italy, was taken with the 400mm lens setting of my 100–400mm image-stabilizing lens. Using this I was able to get a pin-sharp shot, despite a hand-held shutter speed of just $^1/_{60}$sec.

Carrying equipment

When on location or traveling, the expensive equipment you carry can be very tempting to others, especially when your mind is concentrated on the picture opportunities. When working at a tripod do not put the bag down—tempting as it is to get rid of the burden for a few minutes, always keep it over my shoulder. If a thief were to make off with the bag, would you run after it, leaving the tripod and camera unguarded? It is too easy in a bustling market for a thief to snatch a camera bag casually hung on a shoulder—it is much more difficult if carried diagonally across the body.

A bag that doesn't look like a camera bag is a good idea. Better still, use a rucksack to spread the heavy load evenly over both shoulders, reducing the risk of back strain.

Converging verticals

Converging verticals occur when a parallel-sided object, such as a building, is photographed from any height other than dead center. Photographing buildings from the ground ensures that the vertical sides come together at the top. In order to get the top of the building into the frame the camera has to be tilted backwards, and this tilting from the vertical causes the convergence.

The brain corrects this convergence automatically, but the camera does not, and the viewer can find it irritating when looking at pictures with convergence. It seems that the eye favors either virtually no convergence, or very pronounced convergence, where the lines are really making a pattern rather than accurately portraying the subject. I say "virtually no convergence" intentionally, because if the verticals of a building are corrected absolutely it still looks wrong to the brain—slight convergence looks more natural.

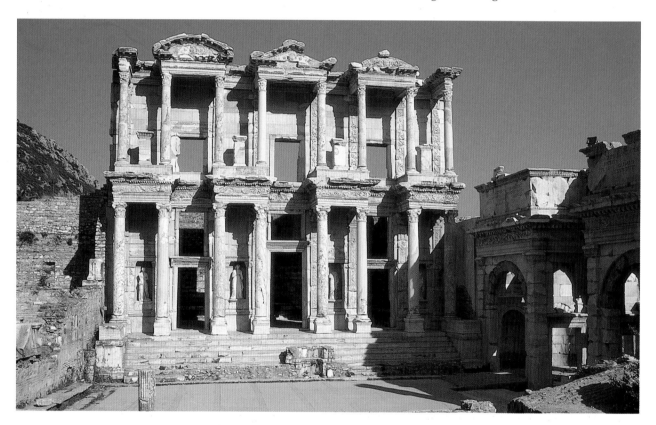

Above: This image of the famous Library in the amazing Roman ruins in Ephesus shows virtually no convergence. It was photographed while traveling with a group of non-photographers around Turkey for three weeks. It had to be taken at this time of day because we were "passing through."

Right: Slight convergence is quite acceptable, and is inevitable when looking up at a building in this manner. This is City Hall, Vienna, Austria.

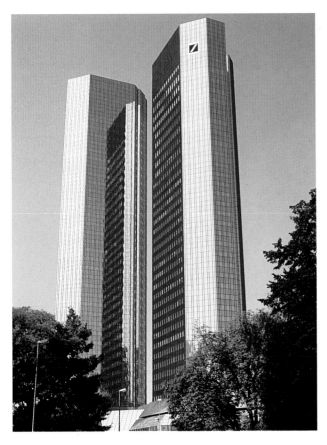

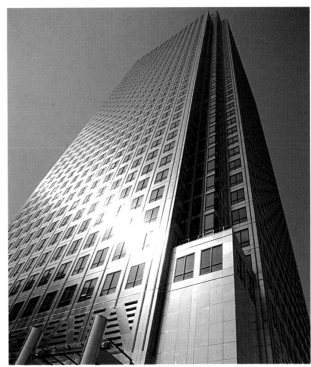

Renting specialist equipment

Unless you specialize in architectural photography, you undoubtedly will not be able to justify buying a shift lens. Similarly, if you only shoot sports occasionally, an ultra-fast telephoto lens, such as 300mm $f/2.8$, would be an extravagance.

You can, however, quite easily rent these lenses from specialist professional photographic dealers. The daily cost of renting a lens, or other piece of specialist equipment you wish to try out, may be just a tiny percentage of the full purchase price to

hire for the day. For a week, you might expect to pay three-and-a-half times the day rate.

If you are renting special equipment for a specific trip or event, it is prudent to book the equipment well in advance, to avoid disappointment, and collect it a couple of days before you need it, to ensure that it works properly, and that you are quite familiar with the controls.

Most hirers will refund the hire charge if you subsequently buy a similar lens—this is an excellent way of trying out an expensive item.

Above left: Skyscrapers in Frankfurt, Germany, show more convergence than the City Hall, Vienna, because the buildings are that much taller. This medium-format image has been a regular seller for many years,.

Above: The convergence here is really pronounced, but it works, and provides an eye-catching image of Canary Wharf, London, England, with the angled light.

However, if the image has vertical walls, lines, or columns very close to the image frame, then these really do need to be parallel to the frame.

There are several ways to correct convergence. The most effective method is to use a camera with movements, and then to raise the lens plate while leaving the film plate where it is. For the 35mm photographer, a PC (perspective control) lens is used, which works in much the same way as a camera with movements, but the degree of adjustment is limited.

The final method is to scan the image digitally and to correct the converging verticals in the image using image-manipulation software, such as Photoshop.

The first two solutions require that you carry the right equipment to do the job; if shooting with a camera with movements, there is no weight penalty. 35mm users, however, will need yet more heavy equipment. Correcting the image digitally has no weight penalty, and means that a variety of different versions can be achieved from the one image.

Filters

Many filters give somewhat exaggerated or gimmicky results, and in most circumstances I feel that these effects are inappropriate for stock photography.

Filters are very important and can save the day, or simply just enhance an already reasonable image, but they must be used with great care and subtlety.

A polarizing filter is extremely valuable for reducing reflections in windows, and in water to make stones on the bottom visible; it can also enrich foliage as it cuts down the bright, reflected light.

Polarizers can also be used to darken blue skies, provided that the camera is approximately at a right angle to the sun. However, when using a saturated film such as Velvia, and a wide-angle lens, you can get a very exaggerated darkening on one side of the image and virtually no darkening on the other, making the image seem quite lopsided. For hand-held photography and with slow film like Velvia, a polarizer can also give real shutter-speed problems.

Graduated filters are really useful to control and enhance the exposure of just one part of the image—for example, a gray grad can be used to darken a pale blue sky, or to reduce the exposure of a very bright

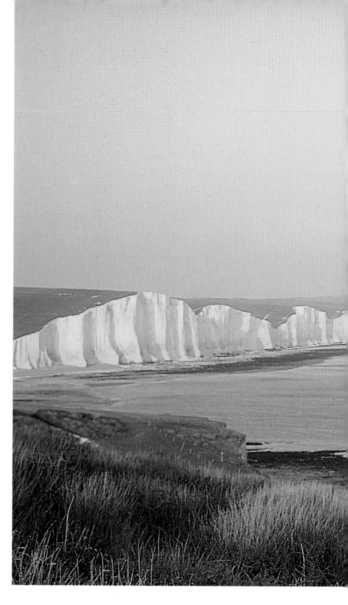

Lens hoods

In stock photography you are seeking the finest quality so as to maximize your sales, and a lens hood is one of the tools you can use to help achieve this. It is quite remarkable how the contrast of an image can be altered when light falls on the front element of the lens. This can easily be seen through the viewfinder by positioning the camera, with the hood off, so sunlight falls on the lens front, then holding a piece of card to block the sun without the card appearing in the viewfinder. It is not just the sun shining on the front lens, it could just as easily be a bright light reflected off water or a window.

With rangefinder cameras the problem is far greater, because even though the flare is not visible through the rangefinder it will still be visible on the film.

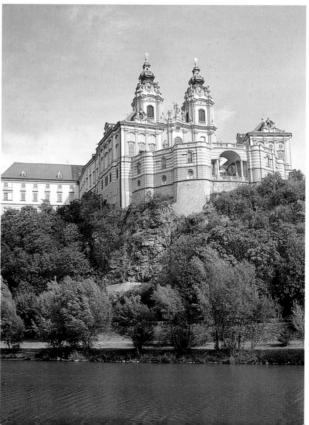

Right: A very pale blue, bland sky spoiled this shot of Melk Abbey on the Danube near Vienna, Austria, so I used a sky-blue grad with a gentle gradation from blue to clear to put some color back. With this enhancement it has been a very successful seller for quite some time.

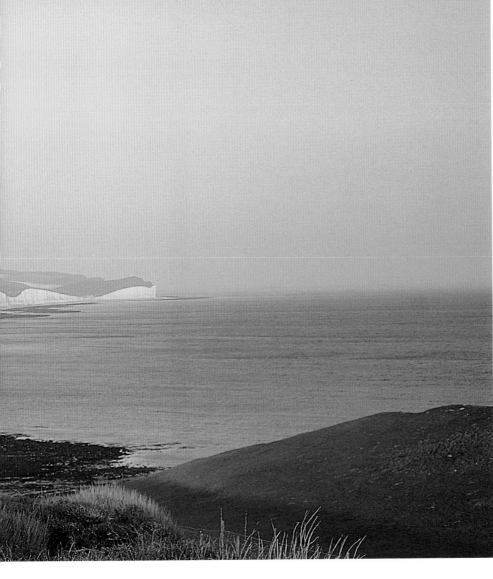

Left: This view of chalk cliffs in Sussex, England, was very pleasant as seen, but it just lacked atmosphere, so I added a very pale grad filter with a gentle gradation from orange to clear. The resulting image has sold very well for book illustrations.

Below: Not much can protect a lens in really hostile conditions like this blizzard near Loch Ossian on Rannoch Moor in Scotland. Use a UV filter so you can frequently wipe the front element clean, and a lens hood to deflect as much snow as possible. Among other sales, this has been used as a double page spread in an international magazine.

sky versus a darker foreground. There are colored grads that are equally useful when applied carefully— a grad is well used when you cannot see that it has been used. A pink grad can give a very realistic sunset, for example, and a blue grad can enliven a somewhat bland sky.

There are generally two types of graduated filters available, one where the change between the color and clear occurs over a short distance, and the other where the gradation is very gentle. The former type poses a risk that the changeover line will be visible, whereas with the latter there is far less chance of spoiling the result. The aperture chosen also affects the degree of gradation visible, so it is always wise to stop down the lens to the taking aperture to preview the final effect.

Correction filters are essential to correct the light temperature; for example, snow scenes usually need an amber correction filter to reduce the blue cast that the snow acquires from a blue sky. Keeping a UV filter on the front of each lens does give the expensive

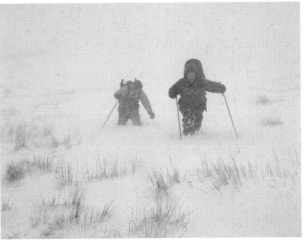

front element some protection, but it can also give unwanted light reflections.

Avoid poor-quality filters. I make it a rule not to put any other glass between my expensive lens and the subject, unless absolutely necessary and unavoidable, to improve the result.

Planning the assignment

What sells to what markets?

Stock pictures are generally required to satisfy one of several demands—they are needed to illustrate a place or situation, to convey a mood or atmosphere, to illustrate a theme or concept, and sometimes just to catch the viewer's attention.

Where do the images end up? Just look around—everything these days is illustrated, and the variety of destinations for stock images is enormous. You think of it, and it can be used!

In essence, all of the different uses to which stock photographs may be put can be divided into three broad categories:
1) They are required for promotion of a product or service.
2) They are used for editorials—illustrating an article or book.
3) They are bought for pictorial use—to catch the viewer's eye on packaging, posters, and so on.

In all these areas the images must be perfect. If the sky is supposed to be blue it should be a beautiful blue possibly with a few puffy white clouds; it should not be a washed-out, pale blue. In fact, the weather must be perfect for that particular type of shot. Any people included should be shapely, clean, and tidy, and preferably of fit and healthy appearance. There should be no garbage visible, and no unsightly objects or people in the background. The image must make the viewer "want to be there." If all the elements of the picture are not perfect, do not bother to even take it—your agency is absolutely sure already to have similar images taken in perfect conditions.

Right: Position in my bestseller chart: #3. Number of sales: 100. Highest single sale: $1,372 (£940). Number of years since first sale: 9. My total income to date: $14,815 (£10,148). This image, the Duomo in Florence, has been used far and wide, from Colombia to Japan. It is one of those magical primary images that clearly says Florence, Italy, and Tuscany. Night shots of cities are usually good sellers. The viewpoint here was a car park on the south side of the Arno river. A very similar shot to this, taken on a more recent visit, is also selling extremely well, having made nearly $4,380 (£3,000) in little more than four years.

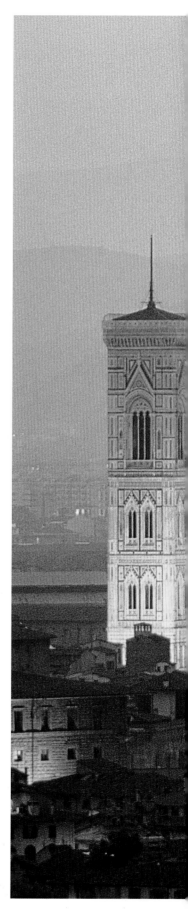

Where they go

An sample list of destinations of my photographs, taken at random from my sales records over just the last three years, is as follows:

Advertisements	Cassette boxes	Greetings cards	Newsletters
Audio-visual	Catalogs	Illuminated panels	Newspaper articles
presentations	CD cases	In-flight	On-line advertising
Banners	Conferences	magazines	Packaging
Billboards	Diaries	Invitations	Posters
Book covers	Dictionaries	Labels	Prospectuses
Book dustjackets	Encyclopedias	Leaflets	Sales sheets
Booklets	Exhibition panels	Magazine	Stickers
Brochures	Financial reports	advertisements	Travel brochures
Calendars	Flyers	Magazine editorials	TV adverts

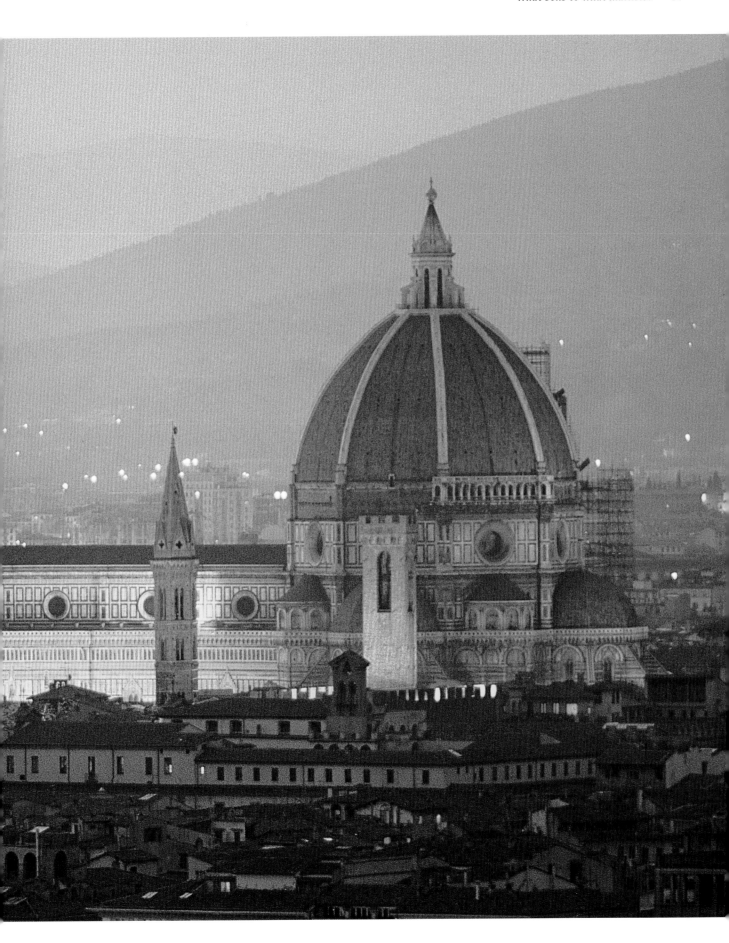

Promotional images

Promotional images are not just those used in advertising. Photographs can be used to promote or sell a product or service in any number of ways. As the list on p. 36 shows, they are needed in a really wide variety of areas, from packaging to CD labels, and from exhibition panels to stickers.

Naturally, a great deal of the demand for images in these areas is fulfilled by commissioned work, but equally there is a really great demand for stock images. Most importantly for the stock photographer, promotional images tend to command the highest prices.

Promotional images of a specific product are usually commissioned, but there is an enormous demand in

Right: This dramatic scene in the Scottish Cairngorms was used by a major watch manufacturer to advertise the strength and durability of their watches. That sale alone paid for the trip, but the image has also been used another 29 times, making me well over $4,380 (£3,000) in seven years.

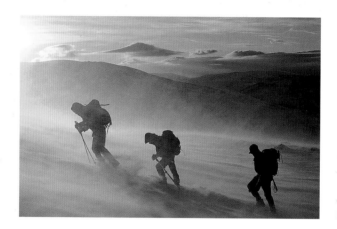

Below: This is unmistakably Monument Valley, Utah, and even though it is only 35mm, this image has managed to sell against strong opposition from medium and large formats.

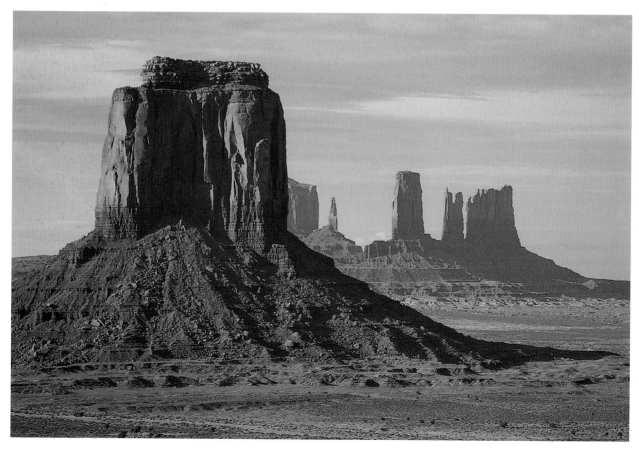

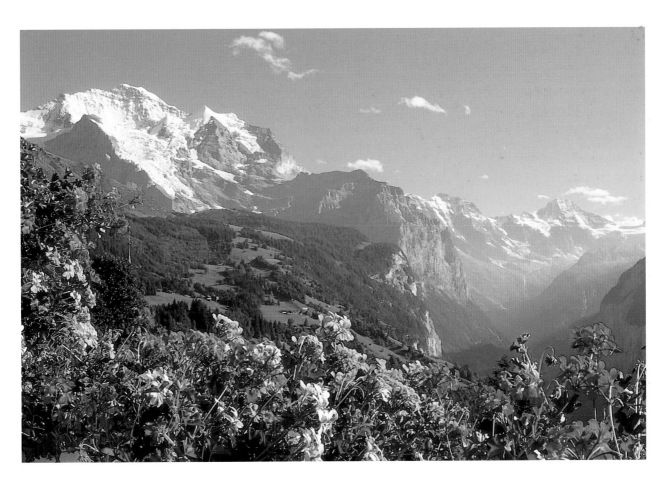

Above: Among many other sales, this image was used three years running by a travel company to promote their holidays in Switzerland—earning three times the fee! The image was shot from the balcony of the hotel in Wengen in which my wife and I were staying.

Right: When walking though the Stadt Park in Vienna, Austria, this statue of the composer Beethoven caught my eye. It has been a rewarding find, and has been used on the front cover of a CD album.

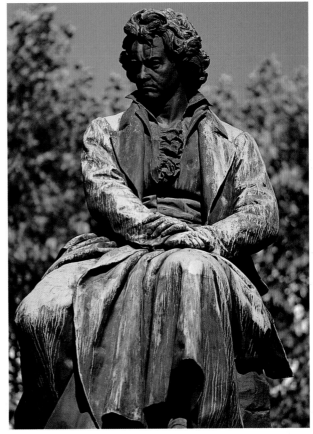

the stock market for the image that supports the product—for example, an image of mountain climbers fighting their way through a blizzard might be used to advertise or promote the sale of a particular camera or mobile phone, showing that it has been built to withstand such hostile conditions.

The promotion of travel around the world is by far the largest potential market for the average stock photographer. The travel industry produces so much literature in every country that its demand is insatiable for perfect pictures of places we all want to go to. And better still, travel companies produce a completely fresh set of brochures every year, as do, of course, the manufacturers of calendars.

Editorial images

Editorial images may not be as financially rewarding as promotional ones, but there is a larger potential demand. These images are used to illustrate magazine or newspaper articles, to aid the text of books, to illustrate resorts in travel brochures, to jazz up pages on websites, and to illustrate audio-visual presentations.

Editorial images may be specifically referred to in the text and must therefore be really accurately displayed—however, they may just play a supporting role in giving the reader an impression. For example, in a travel magazine there may be a specific picture illustrating Wengen in Switzerland, meeting the expectations of the traveler, then there may also be a supporting image of an alpine meadow of flowers. Most editorial picture sales will be fillers, supporting shots that give a taste for an area, rather than illustrating a specific location. This is inevitable because most stock photographers will not find it profitable to cover a subject in any real depth—the sort of depth required to fully illustrate a detailed story. The investment in images for an unknown demand could not be cost-effective.

The best pictures for editorial use are the generic images that portray something typical—a Frenchman wearing a beret on a bike festooned with onions, or a cowboy on a horse rounding up cattle.

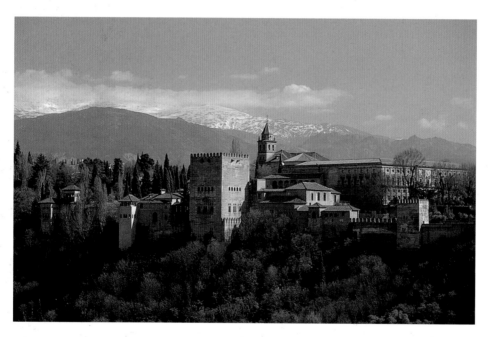

Above: The Moorish Alhambra Palace in Granada in Andalucia, Spain, looks very spectacular from the plaza across the little valley. Even in early summer, there is still snow on the mountains behind.

Right: Images of this slot canyon, Antelope Canyon, near Page, Arizona, are not as obviously "Wild West" as, say, Monument Valley, but they do offer a different angle and are attractive in themselves. This has sold only a couple of times to date, but it is a 35mm image and has to compete with medium and large formats. These canyons are dreadful for getting sand in the camera, because it falls off the canyon ceiling above as you are working!

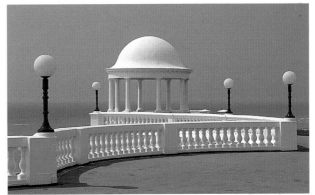

Above: The De La Warr Pavilion in Bexhill, Sussex, England. This type of editorial image could be used to show sights of interest or an architectural style.

Right: The usual portrayal of Rockefeller Center in New York is to show the tower blocks. This rather softer, warmer scene can be captured around the ground-level entrance. This image was shot with medium format.

Below: A generic image of New England in the fall.

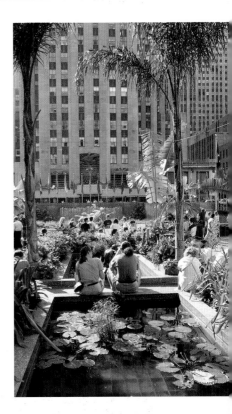

Pictorial images

Some photographs capture images that can stand alone without words. Often they are the pictures that convey a mood or atmosphere, or illustrate a theme or concept. They are the eye-catchers—images that create an impression without the need for any supporting text.

This type of photograph is the one used for book jackets, posters, greetings cards, calendars, and magazine covers. This is a huge area, and good images of this kind can sell time and time again.

Essentially there are two types of pictorial image. First, there are those with an obvious known destination, such as the traditional perfect record shots for calendars, greetings cards, biscuit tins, and, dare I say, chocolate boxes. Then, second, there is the unpredictable market where the photographer can really let his or her imagination and creativity flourish to satisfy the demand in posters and other areas wanting contemporary images, such as specialty greeting cards, CD covers, and packaging.

You can easily imagine a picture buyer asking for images to represent peace and harmony, or ones that portray strength and endurance. An image that simply attracts attention could well be the orange eyes of an owl; one to represent speed and agility could be bike riders jumping high in the air. We will look at the whole area of pictures that represent abstract qualities in more detail in the next chapter.

Understanding that buyers want to use images in this way can help the photographer select and take his or her pictures, and imagining the uses to which a picture can be put will help him or her to compose alternative images from one scene.

I find that these are the most rewarding images to shoot, not only from the financial aspect, but from the pure satisfaction of the creativity necessary to produce an artistic image with visual impact.

Right: Just an eyestopping pretty picture—for a CD cover, packaging, or whatever—taken at Torrieneiri, just south of Siena, Tuscany, Italy.

Left: It doesn't matter where this tree is located—it is the shape and color that catch the eye. Like all good pictorial images, it does not need a caption to explain itself. It was taken at Loch Rannoch, Scotland.

Left: This scene could appear in almost any country that has abundant snow. The image conveys a strong message of cold and bleakness, and words are redundant.

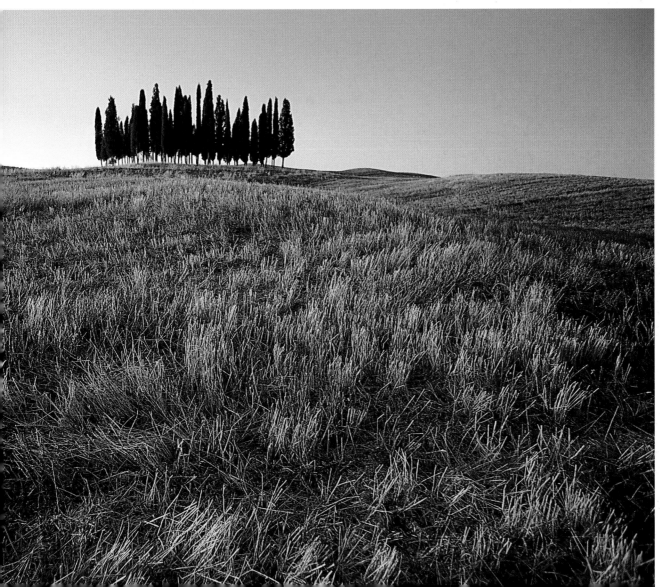

Selecting subject and location

Generally, photographers work best tackling the subjects and places with which they have a strong affinity. If they like the subject matter they will come up with more appealing photographs. This is the first consideration in selecting what and where to shoot.

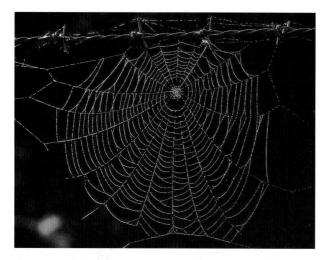

The second consideration is what your libraries want. There is no point taking shots of Chicago just because you like the Windy City, if your library already has more than enough pictures of the Illinois capital on its files. Most libraries are very keen to talk to their photographers before an assignment, in order to improve the sales potential, and they often publish detailed "wants lists" that can be extremely specific. For example, a particular want might be: "Bare-chested white male in 20s or 30s holding naked black baby, aged less than 6 months old." The "wants lists" that I receive from my libraries run into several pages each issue, and there are usually two or three issues each year; sometimes they are just general, and sometimes they are compiled on a theme.

The task is to talk to all your libraries to establish what they want and how they want it portrayed, and naturally this is best achieved if you already have a good working relationship with each library.

With location or travel photography you must always allow plenty of time—the weather and light will inevitably conspire against you if you allow too

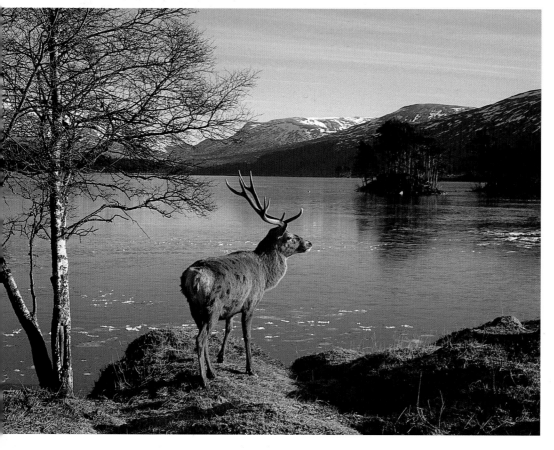

Above left: This was shot in response to a "wants list" item by one of my libraries. They had obviously been asked for spiders' webs and had been unable to fulfill the request. Photographers might see this as a wildlife subject, but buyers might use it to illustrate a concept such as entrapment.

Left: I came across this beast on the shores of Loch Ossian in the Highlands while trekking in winter. The stag symbolizes Scotland as much as the scenery, and the shot has had many successful sales, including as a postcard for a local trekking organization. Just to the left of the shot is a hostel for hikers—what you exclude from an image is as important as what you include.

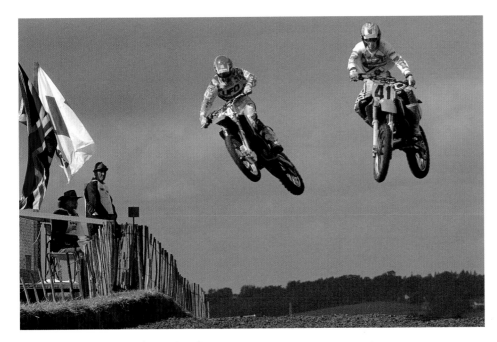

Left: This shot was taken at a national event taking place just a few miles from where I live in Sussex, England. I am not really a sports photographer, but it was too good an opportunity to miss. When submitting this image, I added some key words to the caption to stimulate the library editor's brain, such as "speed" and "agility."

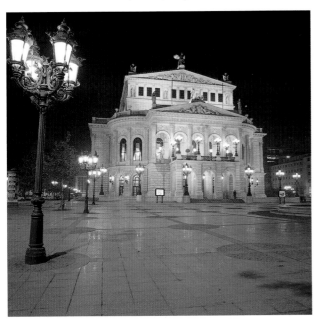

Left: A most photogenic building in its night-time illuminations, this is quite clearly a very representative image of old Frankfurt—and a stark contrast to the skyscrapers of the German city (see p. 31). Shot, on medium format, at the suggestion of a stock library.

Above: This generic shot of fall, rather than of a particular variety of maple, has frequently been used as a "filler" in books and magazines, thanks to its eye-catching color and graphic composition.

little time. A few great shots are worth more than a lot of mediocre images, and are much more rewarding to shoot. Remember, a single shot, such as my top 12 bestsellers shown in this book, could make you thousands. It is quality, not quantity, that counts.

Even if an assignment is not imminent, it makes sense to always know what your libraries want so that images on the wants lists seen in passing can be captured. Decide your subject areas and prepare accordingly, but bear in mind that animals and flowers require specialized knowledge and treatment, and need accurate captioning with the Latin name as well as with the more common description. Sport is another very specialized area, usually requiring intimate knowledge, and the access to get to the best viewpoints, which may need official accreditation to be reached. Sports photographs can also date quite quickly.

Generic and non-specific images of flora, fauna, and sports do have a reasonable market—for instance, poppy images and sunflowers to represent summer, animals to represent a concept or theme, or sports images to represent speed and agility.

Making a shooting list

Having selected the subject and location, it is wise to prepare a shooting list, because this focuses the mind on what is really important. The list can be prepared from information gleaned from the libraries and from other sources such as travel books, guide books, newspaper and magazine articles, travel videos in public libraries, and conversations with other photographers. The internet is also an invaluable reference source. Accessing photo library sites will allow you to see the pictures that have been shot by other stock photographers, and will help highlight areas where a particular agency seems to have weak coverage.

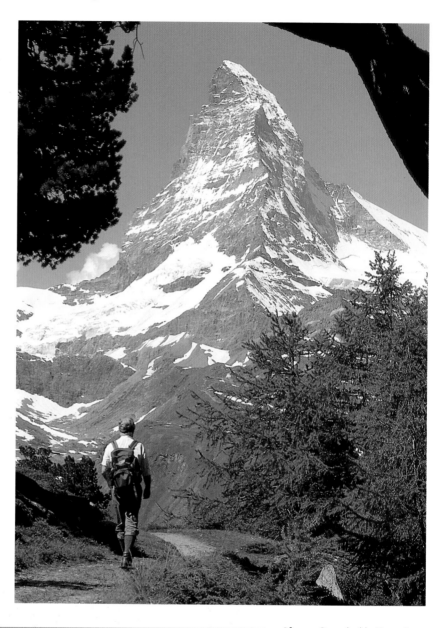

Right: The Monte Rosa above Zermatt in Switzerland, seen from Gornergratt. The mountain scene is pretty, but does need the figure to bring it to life.

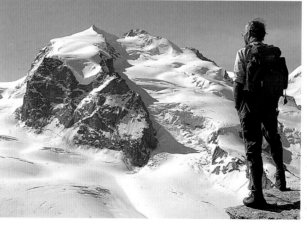

Above: On arrival in Zermatt we studied the local guides and postcards, and this image of the Matterhorn was very prominent. With research on the map we found the location and replicated it. The model is my cousin, who, being an accomplished photographer, has an empathy with my requirements.

Before every trip, I ask the libraries for whom I shoot whether they have any particular requirements from my chosen destination, and more often than not they will give me details of the images they want, and how they would like them portrayed. I also download street maps from the internet, to establish the logistics of getting from one subject to the next, and to serve as a guide to initial viewpoints and timings.

I then prioritize the list so that if the weather or light are no good for the first few days, I know what must be done if and when the elements improve. If the weather is good at the outset, I always shoot the priority subjects first in case conditions deteriorate. On many occasions the weather has made shooting unrealistic for several days, while a weather pattern moves through the area. This lessens the number of days that I can shoot, so the prioritized list is invaluable. If the weather or lighting is poor, of course, you can still use the time wisely, hunting out the best vantage points and best times of day, so that when the conditions do eventually change, you will know exactly which shots you need to take.

A few years ago I was in Zermatt, Switzerland, for seven days, and the first six days were hopeless for photography. On the last day, however, the weather was perfect, and thanks to earlier planning and careful logistics, I was able to return home with some very salable images.

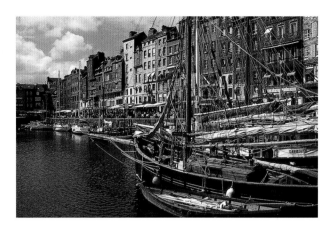

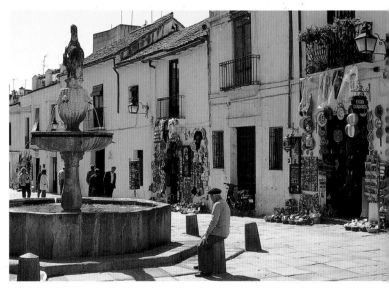

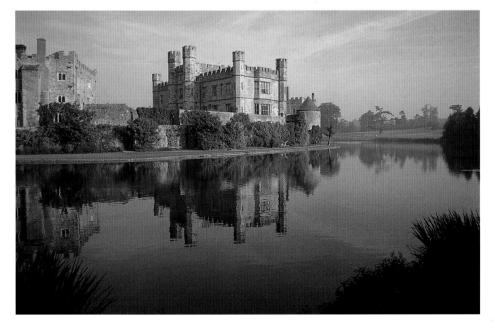

Top: Honfleur is a quaint port in Normandy, France. We were there for three days, and only had a couple of hours of usable sunshine .

Middle: One library had asked for typical Andalusian Spanish scenes, and this little image obliged nicely.

Left: Leeds Castle in Kent, England, shot with a little faint mist for atmosphere.

New angle or old?

Once you have arrived at your location, it always pays to do a bit more research by studying postcards of the area. The local photographers' images can give very good clues as to "must-see" places, subject treatment, and viewpoint, and the worst of the cards will show you what not to do.

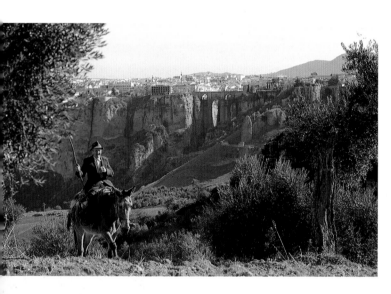

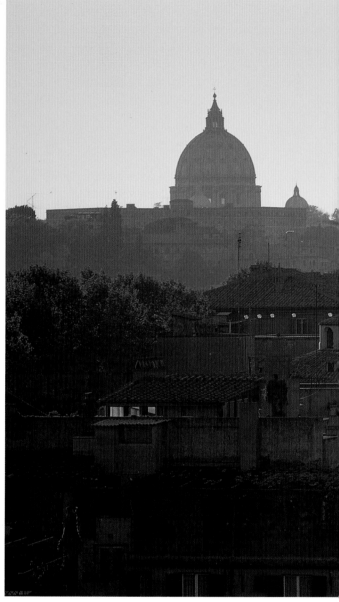

Above: Just when I was despairing of being able to get a new angle on the pretty white village of Ronda in Andalusia, Spain, along came this miserable old local on his long-suffering mule; I had to dodge a swipe from his stick!

Right: I asked the manager of my hotel in Rome, Italy, if I could get on to the roof to get an unusual viewpoint of this well-photographed city; he obliged. This medium-format image has sold to a Sunday newspaper color supplement.

When you are photographing plsces, local bookstores usually have publications on the locality, which provide useful insights. Quite often, when picture buyers ask for an image of a place they want one similar to those already on file, but with a unique sparkle. They want it to be similar, because that way readers will instantly recognize the place by that image, but it needs to be different enough to whet the customer's appetite. Therefore, it is very worthwhile seeing the various treatments used by local photographers, who are used to being surrounded by these subjects all year long. This then allows you to decide which are the best viewpoints to use in limited time, and then to prioritize them.

It is also worth trying to identify unusual vantage points that would not have been widely used in the past. The manager of your hotel, or a shop, or café, may be obliging and let you on to its roof; such bird's-eye views can provide distinctive images, and also offer new angles on familiar subjects. You have to imagine the picture buyer sifting through 20 or 30 images of a subject—the one that will catch his or her eye is the one that stands out, whether it uses an unusual viewpoint, or simply a different foreground.

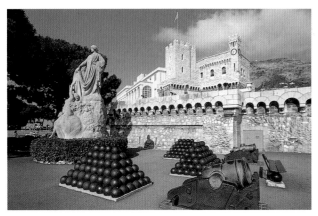

Left: The palace in Monaco has been shot from every viewpoint, so getting one with a little variety required walking all around a couple of times. This has been a very reasonable seller, considering the limited demand for the subject matter.

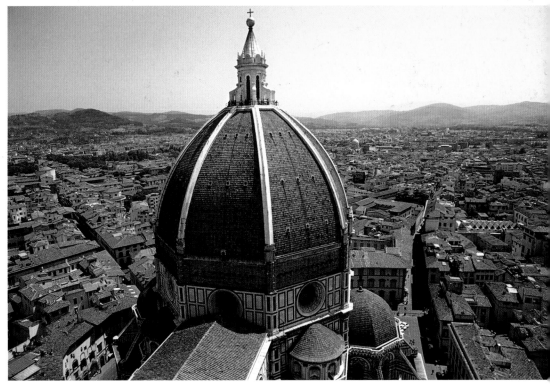

Right: A different angle on the St Francis Basilica in Assisi, Umbria, Italy, is difficult to find. Here I used a large foreground covered in flowers, found on the approach to the town.

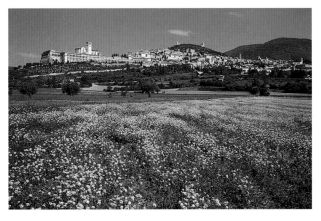

Above: High-level shots like this always do well; they show an angle that few of us get to see, and therefore give that extra something the editor and picture buyer are seeking. This view from the Duomo in Florence, Italy, has been an excellent seller, having been bought 12 times, with the largest single sale netting me $950 (£650).

Locations and permits

Location shooting requires detailed planning, preparation, and reconnaissance to determine the best time of day (and sometimes even the best month or season), as well as the most rewarding viewpoints.

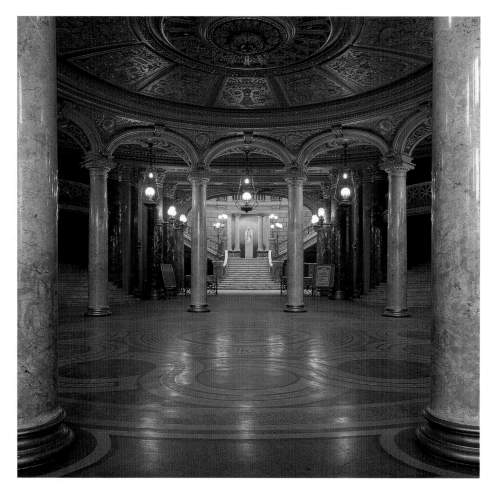

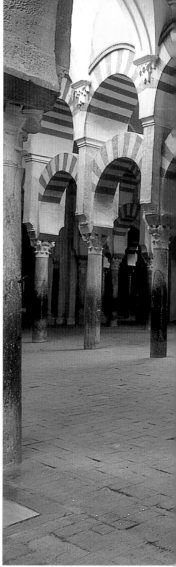

Left: There was no problem photographing the interior of the Opera House in Bucharest, Romania, but we did have to find some more light bulbs because many were missing! Shot with medium format.

It might not be feasible to get the shot that you were looking for at that point in time. Some viewpoints will be obscured by building works or other features, which mean that a return later would be a more productive option.

Upon arrival at a location, the immediately obvious viewpoint is quite often not the best. However, who is to say what is the best? But you don't have to choose between the different viewpoints—different buyers will undoubtedly choose what they can use. For stock, therefore, you want as many versions as possible, to give variety for multiple submissions. You need to completely cover the subject from every angle,

far and near; having spent the time and money to get there, it would be uneconomical to do otherwise.

Even if you are taking your subject with you, as with models, it is equally necessary to establish the location and timing to show the subject in the most favorable and appropriate situations.

Interiors often have restrictions imposed on photography and you may need to get permission from the appropriate authority, and probably pay a fee. In some cases, advance warning is necessary; when I was in Romania, hoping to photograph the interior of Ceausescu's palace (now called The House of the People), I was told that I needed to give 28

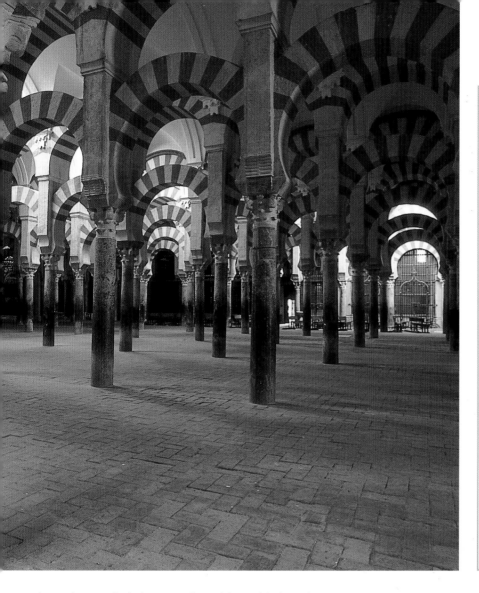

Above: The Mezquita is the mosque in Cordoba, Andalusia, Spain. It is a really difficult edifice to capture. The inside is vast, with 750 columns, and a Christian cathedral in the center. When I put up my tripod an official told me to move it, so I thought I was about to be thrown out, but then he politely showed me a far better viewpoint, the one you see here. This photograph has sold 19 times and has paid for the trip five times over.

days notice in writing—they knew of course that I was only staying for a another two weeks.

For most stock photographers, paying the fee for indoor shots is really uneconomical, because we are not shooting on a commission, and therefore don't know whether we will ever recoup the fee. We are shooting "on spec," and cannot be sure whether a picture will ever sell. With many establishments charging more than $350 (£200) for a day's shoot, this makes the whole prospect unappealing.

It is most frustrating to see tourists snapping away and being unable to set up a shoot yourself, but this is just part of taking photographs for profit.

Above: The House of the People in Bucharest, Romania. I didn't have enough time to get a permit for the interior. This medium-format image of the exterior, however, paid for the trip on its own.

Packing and paperwork

I am often asked for advice about the practicalities of assignment plannding and packing equipment for airline flights. The first thing is that film, unexposed or exposed, must never ever go in luggage destined for the hold—this gets a really hefty dose of X-rays that will certainly fog the film.

The cabin baggage allowance for economy passengers is usually around 13.2lb (6kg) for scheduled flights. 35mm film weighs only about 1oz (35g) per roll, but 50 rolls weigh 3.1lb (1.75kg). Other things that you will want to take into the cabin might include a bag, cellphone, sunglasses, book, and other personal essentials—on average, this can total 10lb (4.6kg), leaving a mere 3.2lb (1.4kg) allowance on a scheduled flight to take camera equipment aboard.

The remainder of the equipment, therefore, must go into the checked-in luggage in the hold. To keep the weight and bulk to a minimum I pack this equipment in bubble wrap and place it in between clothing. I have a tripod that will pack in my check-in luggage. To minimize weight it is made of carbon fiber, and the head and center column are removed to shorten its maximum length.

Batteries
Always carry plenty of spare batteries. In really cold conditions, where they run down more quickly, take four or five, and keep them warm in your pockets.

Insurance
It is wise to have insurance coverage for your equipment, but more important it is essential to have public liability insurance, both at home and abroad. In this increasingly litigious society, if someone were to trip over your tripod, you can be sure they would sue you.

Security of exposed film
Exposed film can be worth more than the equipment. The latter should be insured, but exposed film is unlikely to be. Treat it with the same care you would give a credit card or cash. Keep the rolls sealed in air-tight canisters and bags to keep out dust and dirt, and refrigerate them whenever possible. I always keep the canisters in a particular section of my bag that can be zipped shut, to save them falling out unnoticed. I also send film to the processors in batches, rather than all together, so that if anything goes wrong, I don't lose all the pictures from an assignment.

Visas and customs
Visa requirements will often be different if you are entering the country as a working photographer. Some countries may categorize a professional photographer as requiring a business visa, as opposed to the easier-to-get tourist visa. Some countries restrict the amount of equipment that may be brought into their country, and may even require a deposit (to ensure you don't sell the equipment while you are in the country). It will pay dividends to establish all this before setting out. Keep a list of all your equipment and the appropriate serial numbers, and carry photocopies of the purchase documents, to prove you did not buy the equipment locally.

Income, expenditure, and tax
Your earnings from libraries should be detailed and declared as income to the tax authority. However, the expenditure directly related to deriving that income can usually be set against the tax due. Depending on the tax rules in force in the country where you live, this may well include all travel and subsistence expenses, film and material cost, insurance, and so on. Usually it is possible to include an allowance for the acquisition of capital goods, such as cameras and computers, where the allowance is based on an annually reducing value of the equipment. The advice of an accountant could prove a wise expense if you want to maximize your investment from your stock photography.

For the professional this whole process of income, expenditure, and tax is second nature, but to the amateur it may be new territory. The fundamental rule is to keep all receipts, invoices, and tickets, so that any expense can be proven.

Right: Position in my bestseller chart: #4. Number of sales: 139. Highest single sale: $2,254 (£1,544). Number of years since first sale: 4. My total income to date: $14,616 (£10,011). This shot has sold more times than any other I have taken, and it cost so little to capture—two rolls of 35mm film. It is a view of my local highway from a bridge over the road. Several long exposures were taken to ensure one perfect image, and then the bracketed sequence was repeated many times.

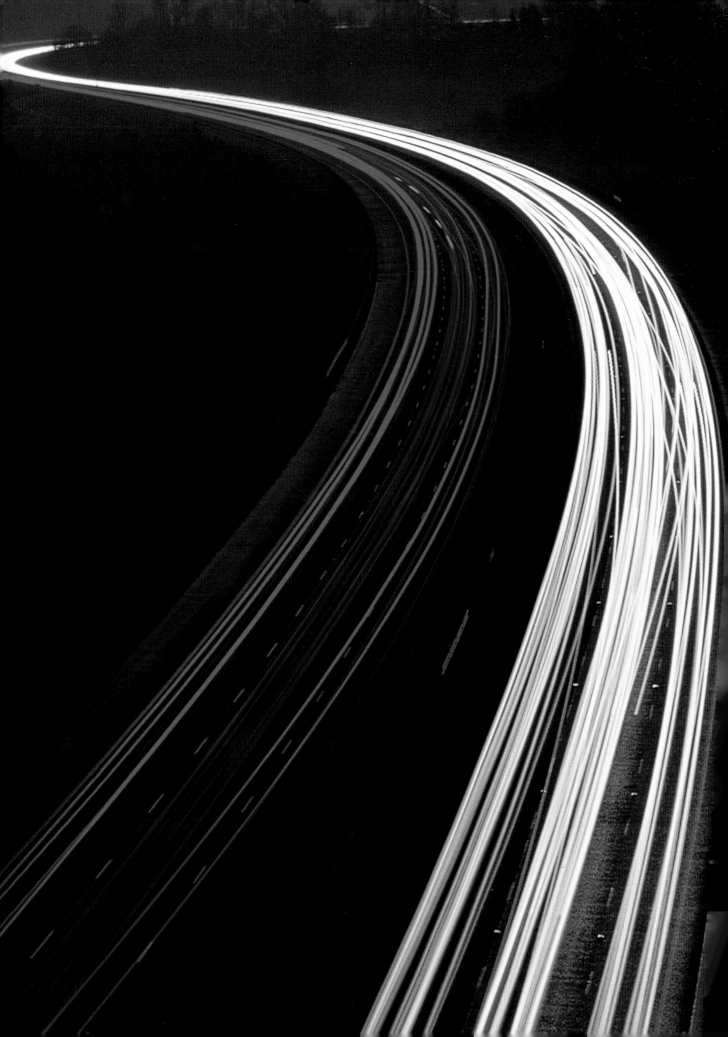

Selecting the subject

Primary images

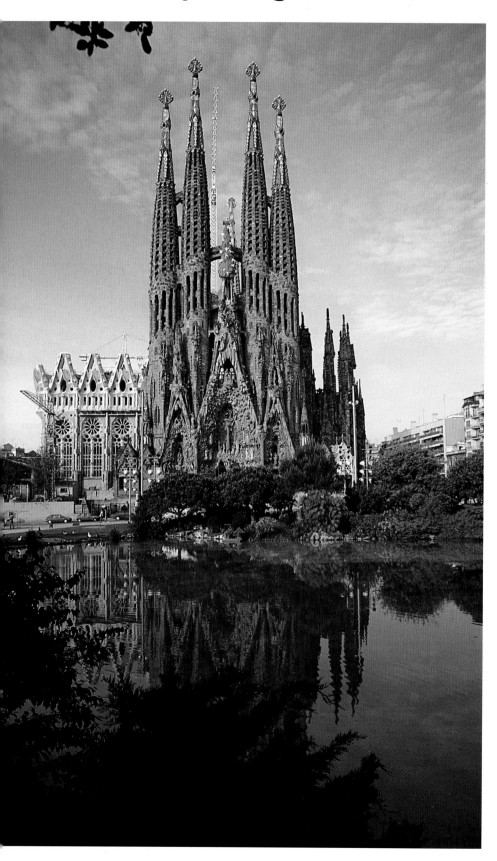

Where images are required to illustrate cities, countries, and well-known places, the greatest demand is always for the most obvious shots. When most people think of Paris, what is the first thing that comes to mind? For the majority of people it would be the Eiffel Tower. Everyone who sees a picture of the famous iron tower will recognize it, and will know the city and country in which it can be found. For the picture buyer, the fact that the landmark is so recognizable, and so photographed, is a huge bonus. A shot of the Eiffel Tower is far more evocative of France and Paris than, say, a shot of the Pompidou Center or even the Sacré-Coeur, and therefore will normally be sold more frequently.

Left: Sagrada Familia, the Gaudi-designed cathedral in Barcelona still being built, and probably the only image of this Spanish city that instantly says "Barcelona."

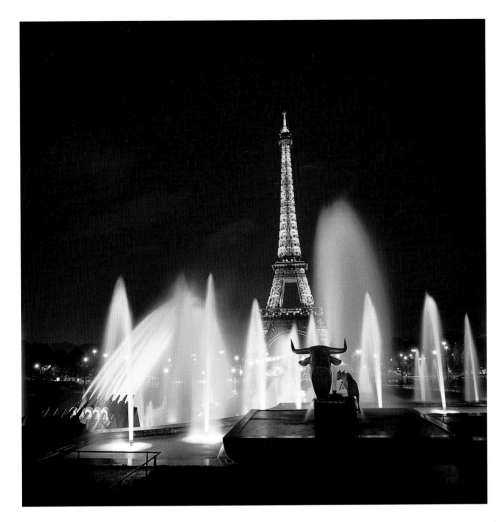

Left: No one needs a caption to tell them that this is the Eiffel Tower, or that it is in Paris. It is this instant recognition that make such pictures so successful for the stock photographer.

Below: There are many images that immediately say "London" to most people in the world—Big Ben, the Houses of Parliament, red double-decker buses, black taxicabs...and, of course, Tower Bridge.

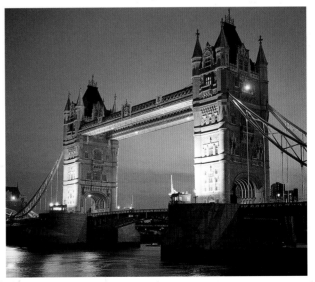

You can easily imagine a picture buyer wanting to illustrate a company's accounts and annual report, and needing an image that says "France" to illustrate the section on their French operation. A shot of the Eiffel Tower would be the most obvious choice.

For many cities and countries, it is is not difficult to identify the images and locations that summarize the place. For China, it would probably be the Great Wall. For Sydney, Australia, it would be the futuristic Opera House, and for Washington DC it would have to be the White House. The difficult bit is photographing the place in such a way that it stands out from all the other hundreds of images held on file at the photo library.

Many years ago I looked at the images of the Taj Mahal held at one of the big international agencies. There were over 500 photographs of this famous Indian mausoleum, and every single one was different in some way or another. They each had just a little something to make them special, such as a wonderful sky, mist, or foreground interest. Nowadays it is easy to perform this exercise, so that you see the variation in styles and approaches used by different photographers on a particular building. All you need to do is to enter the name of the place or building in the search engine of a library's website, and all the shots held can then be seen on your computer screen.

Supporting shots

When photographing a city, it is the "primary" shot, or, as some libraries call it, the "establishing" shot, that is likely to sell for the largest sum. This is simply because it is usually going to be used more prominently and shown larger—both attributes that govern the price.

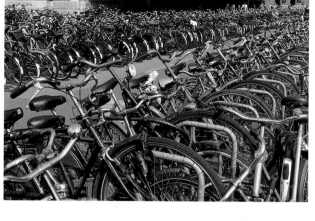

Above: When you visit Amsterdam, the proliferation of bicycles is astonishing—nowhere else in the western world are there so many. This image is used as a filler in conjunction with primary images of Amsterdam or Holland.

Opposite: Typically Venice, Italy, but this is quite clearly a supporting or secondary image to one showing the lagoon with San Giorgio or San Marco.

Left: This shot of lavender fields has been used many times to add color and to support more pictorially descriptive images of the Provence region of France.

But this is not to say that other images are not worth doing—they certainly are. For every city or country there are thousands of typical and interesting scenes that can be used to illustrate the location.

Because it is possible to find so many supporting images, the photographer can still make a very healthy income from this type of picture. Each shot might sell only occasionally—but you can supply so many different images, which all have a chance of being sold at one time or another. Primary images might sell for more, but you will have a far smaller number of these.

Individual supporting shots can also turn out to be gold mines, although it is not always easy to predict which these might be. I was once photographing Vienna, Austria, and just happened to pass a statue of Beethoven tucked away in a park. This image (see p. 39) has sold repeatedly for several years, including for use on the front of a CD box.

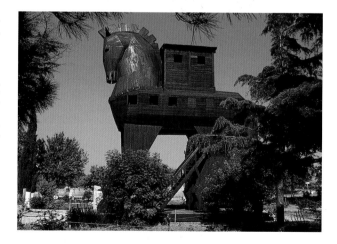

Above: We all know the story of the Trojan Horse, so this image says Troy, Ancient Greece, and Turkey. The shot has been used several times in articles about the legend.

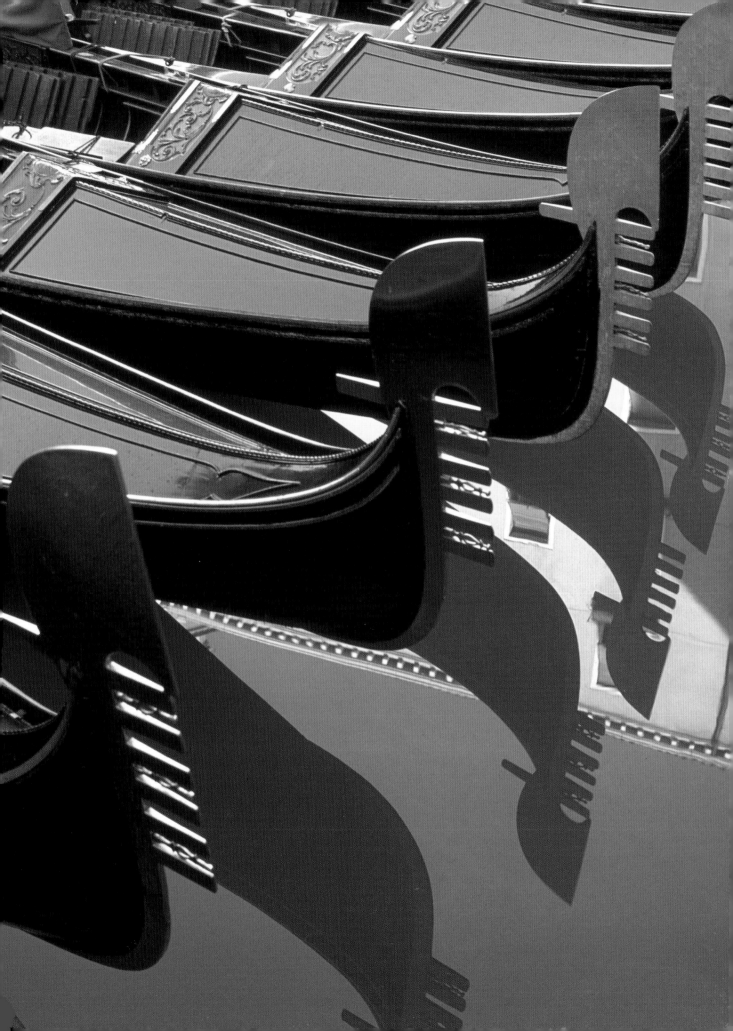

The right time of day

The time of day that you choose to capture a city is fundamental for a variety of reasons, the most important of which is to portray the subject at its best. But there are many secondary considerations, such as ensuring that there are no shadows from buildings blocking, or even half-blocking, an important feature. Furthermore, you might discover that there is a lot of garbage and litter in the afternoon, and that it is best to get to the location just after the street cleaners have done their work in the early morning. At many popular locations in a city, you may well find the place teeming with tourists by mid-morning, all carrying ghastly, unphotogenic plastic shopping bags.

The time of year also has an effect. Midday light in summer is usually very "overhead" and does not do justice to buildings. Winter light is usually crisper and freer from pollution, and in northern and southern latitudes it does not rise directly overhead, so the light is more directional, thus improving the contrast in the structures. On the other hand, low-angled light does not get down into the skyscraper "canyons" of modern cities.

Below: Buildings must be caught in the best light to suit them. It was important here to ensure that the curves of the dome were properly lit to show them at their best. Note the strong foreground that gives depth to Brighton Pavilion, Sussex, England.

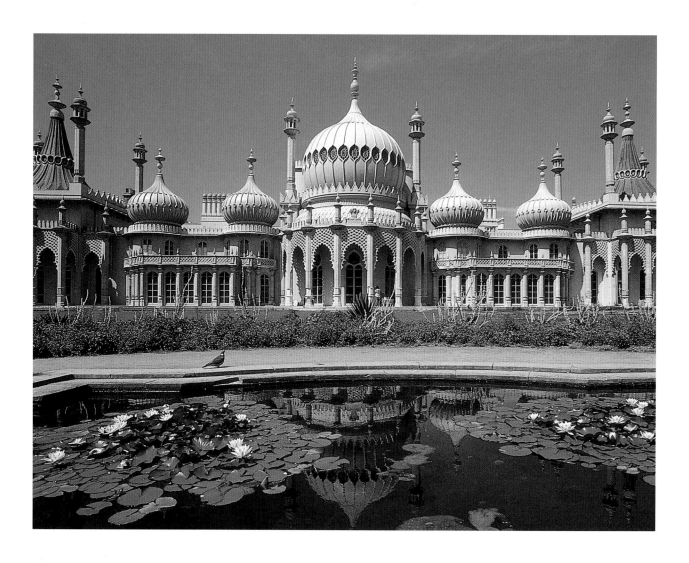

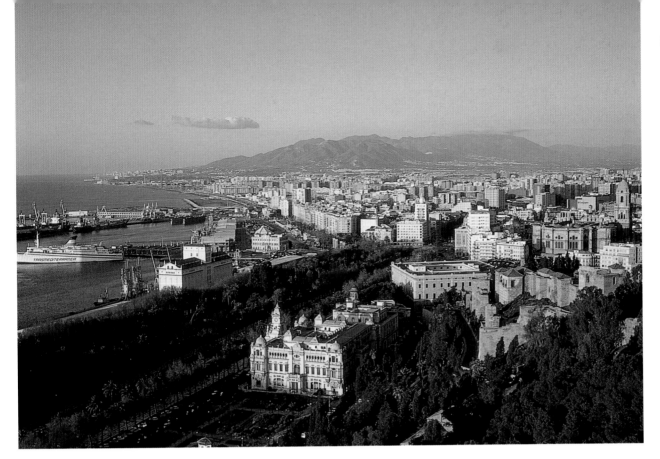

Above: Not the usual view of Malaga, Spain, but this new angle in this fabulous light has been a firm seller for some while. It was shot from the old castle ruins—a place to be avoided when alone at night, but possible in early morning.

Left: In midday light Glasgow Cathedral, Scotland, is really black and dull—the viewpoint and time of day had to be selected carefully to provide a worthwhile image. This photograph is now selling well.

Foreground interest

Landscapes and country scenes are just as tricky as shots of buildings, but for quite different reasons. It is easy to take a photograph of a section of beautiful countryside in perfect light conditions, but more often than not when the photographer gets the image processed, and views the photograph for the first time, he or she will feel that there was more to the original scene than seems to have been captured.

Very often, a beautiful landscape scene is no more than a background, and the bottom half of the photograph can therefore often look empty and uninteresting. The photographer must search around the scene to find a foreground to add to the lovely background. An example might be where the photographer is looking across fields to a pretty valley beyond; the five-bar gate that he or she is leaning on could be the foreground interest—include the open gate leading into the fields, and the image comes alive. Flowers and interestingly shaped rocks also make very successful impromptu foregrounds to landscape shots, and all you have to do is to get down low enough and close enough to them so that they use up the space at the bottom of the frame well.

It is also important to realize that by finding alternative foregrounds, you can increase the salability of your pictures. A different and significant object in the foreground could mean two separate pictures, which could be submitted to different libraries (see p. 57 for more discussion on the subject of "similars").

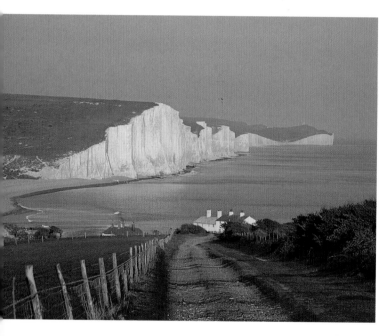

Above: This is essentially the same image as that shown on p. 16, but it is an entirely different rendering at a different time of day and year—this image feels warm and friendly, while the other is cold and stark. Both images have a substantial foreground to lead the eye into the center of interest, giving good depth.

Right: The image here without the sunny grasses would be nice but lacking in interest. The well-lit foreground gives sparkle and punch. I was camping at Le Balze, near Volterra, Italy, and when I looked out of my tent in the morning this was the sight that greeted me.

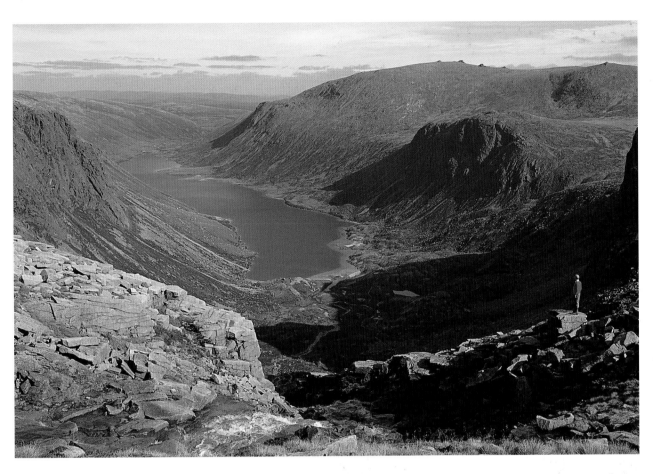

Above: It is helpful if you can get the person you are traveling with to wear suitable clothing. My cousin poses in his photogenic red sweater and gives the wide expanse of Loch Avon, seen from the Cairngorm summit in the Scottish Highlands, scale and depth.

Below: I have visited Blea Tarn in the English Lake District many times, and have never seen it as still as this again. The clarity of the water, the stones in the foreground, and the reflections make this picture a popular seller.

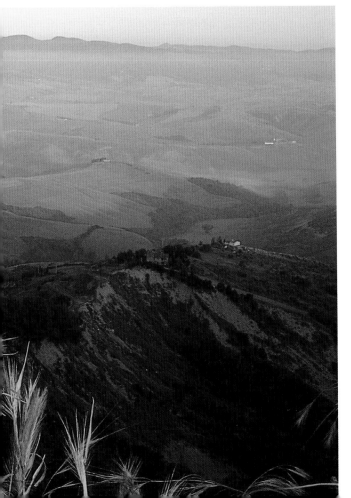

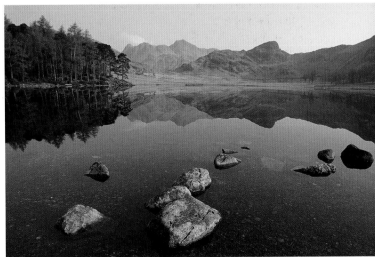

Themes and concepts

It is easy to imagine a picture editor wanting an illustration to go with an article about teamwork. But what can the photo library provide that meets this brief? In fact, when you start to think along the right wavelengths, the range is extremely wide. For example, a pack of lionesses hunting shows teamwork, as does an image of rowers in an eight, all pulling together. Likewise, the magazine might want to represent "differences," and for this example you might think of a well-known saying such as "'like apples and oranges," or a shot showing a pair of identical twins in very slightly different outfits.

Naturally, there will be great demand for images portraying moods and atmosphere, and typical examples of these themes abound in the landscape field—misty sunsets, frosty dawns, crisp white snow, and the colored leaves of fall.

When a library is searching its files for an image to satisfy a buyer's request, it is essential that the image be captioned and keyworded accurately, otherwise it will not be selected. That means that an image of

Below: In the Masai Mara, Kenya, we tracked these cheetahs for two hours until they suddenly provided this wonderfully enigmatic shot. This can be used to say so much—teamwork, communications, hunger, friendship...

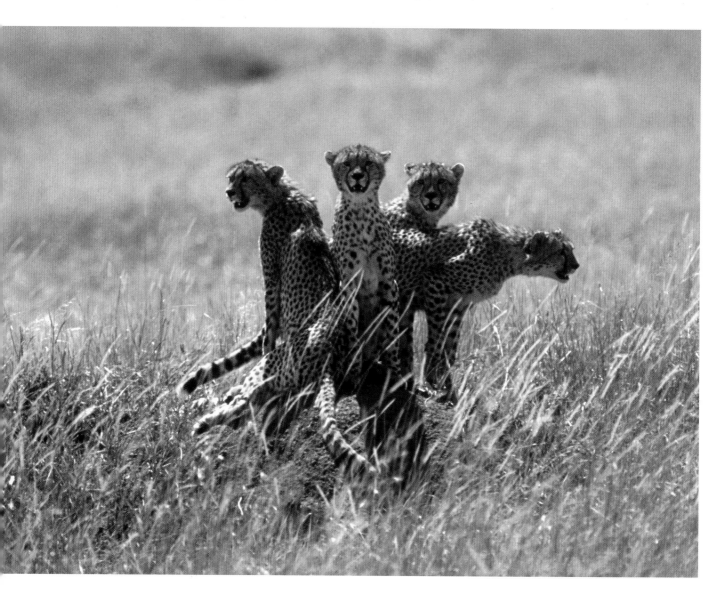

Starting points

To give you a flavor of some of the possibilities, and to get you thinking along the right lines, here are some suggestions:

Achievement—climber at top of mountain, bulbs pushing through snow

Affluence and success—sports car, luxury yacht, trophy cabinet

Against the odds—tightrope walker, paralympic athlete

Ancient and modern—old cathedral reflected in glass of modern office block

Balance—unicyclist, gymnast on the beam

Building—bird with straw in beak, crane

Calm—perfectly still lake or sea

Celebration – fireworks, champagne

Chance and risk—gambler at the races or roulette table

Communications—person using megaphone, line of mailboxes, parrot, lighthouse

Contentment—cat basking in sun

Destruction—wrecking ball, lightning

Directions—close-up of compass roadsign at crossroads

Fear—threatening sky, lightning, ghost train, spider on a child's palm

Good luck, bad luck—horseshoe over entrance, door sign saying number 13, broken mirror, group of magpies

Grace and motion—swans on lake

Greed and need—window display of cake shop

Growth—growth rings on cut-down tree

Harmony—choir, tranquil landscape, flags flying together

Little and large—toddler's shoes next to man's boots

Loneliness—solitary figure on beach, tramp

Love—statue of Cupid, heart carved into bark of tree

Memory—elephants

Mystery—crop circles, stone circles, henges

New dawn—sunrise

Passage of time—worn steps of stone staircase, decaying fruit, sequence of snowman melting

Peace—dove, flower embroidered on hippy's jeans

Power and energy—steam engine, windmill, cooling towers

Progress—three-quarter-harvested field of wheat

Race against time—hamster in treadmill

Ready for action—meerkat on hind legs

Seasons—fall can be illustrated with shots of colored leaves, winter can be displayed with frosty or snow-covered landscape

Skill—juggler, craftsman at work

Speed—greyhound running, Concorde or fast airplane

Strength and endurance—tug-of-war team, ant carrying leaf

Teamwork and cooperation—rowers, rugby scrum, pack of huskies

Time and timekeeping—picture of watch or sundial (such as the best-selling shot shown on p. 72)

Vulnerability—beekeeper at work

Wisdom—picture of owl (such as the best-selling shot shown on p. 23), selection of old books

Young and old—acorn with mighty oak

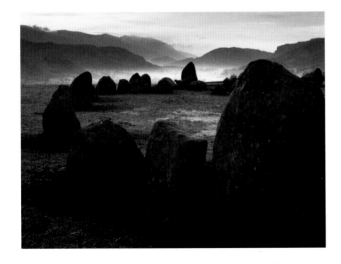

Above: Castlerigg stone circle, near Keswick, Cumbria, England, is a very evocative scene that suggests mystery and folklore. I actually found black and red candle wax on the middle stone of this ancient monument.

mountain climbers, for example, should not only state the obvious about location, but include such cross-referencing keywords as teamwork, strength, against the odds, and so on.

There are literally hundreds of themes and concepts; the list is as broad as your imagination. The agency will normally be able to supply the photographer with a list of such concepts, which will stress the areas where they need additional images. I was once given a detailed list from an agency that ran to nine pages and included lists of the images that could be used to illustrate each theme or concept.

I have found that thinking along the lines of themes and concepts enriches my creativity, and helps me to see images that I would have otherwise missed, or did not feel worthwhile. A very large proportion of images selected by buyers is in this category. The buyer, editor, or advertiser is trying to illustrate a mood or atmosphere, theme or concept, and the image itself is less important than its message.

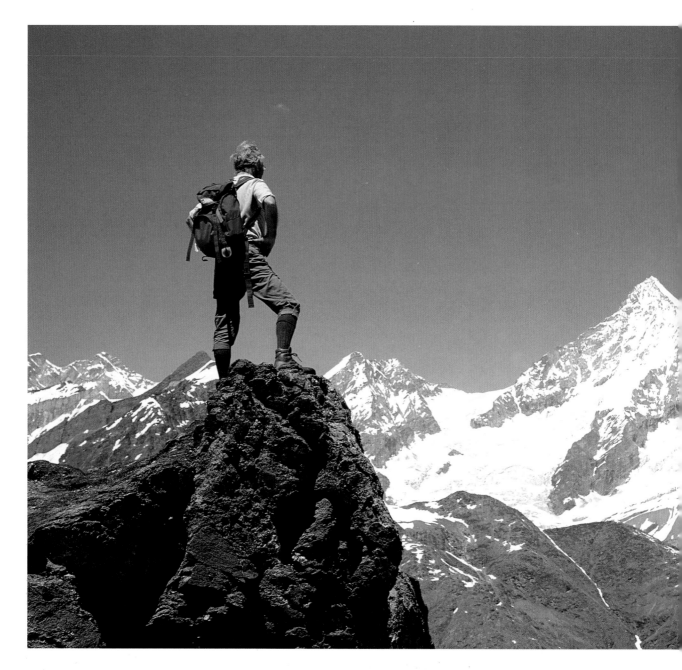

This is the area that is really satisfying for the stock photographer; he or she can let the imagination roam, and make creativity work overtime. When it comes to captioning, the photographer must make sure that the editor in the picture library is on the same wavelength. It is no good just sending in a well-captured theme photograph with just the normal factual caption; the editor may be too busy to see what you did, so it is essential to stir his or her imagination with your theme description. A good editor will then probably think of several more ways to keyword the image so it can be readily located (captioning is discussed in more detail on p. 102).

Left: The Weisshorn, taken from the Ritzengrat Ridge, 5,000ft (1,500m) above Zermatt, Switzerland. I was climbing with my cousin, who kindly obliged with this perilous pose. This not only brings the scenery to life, but it also means that the shot could be used to symbolize such abstract qualities as "achievement," "aiming for the top," or "peak performance."

Below: The central stained-glass window above the altar in St Peter's in the Vatican, Rome, Italy: an apt image for peace. The hands and people are part of the window, not tourists getting in the picture.

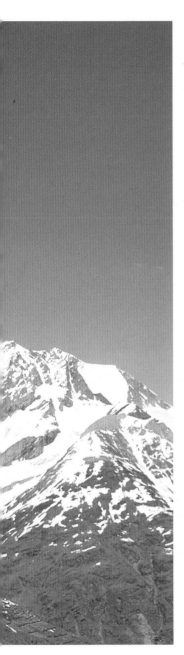

Left: Poppies perfectly portray summer, or are a symbol for remembrance. When shooting flowers, try to shoot into the light so that you get some translucence in the petals.

Right: The subject here is my climbing partner, so there were no modeling fees—just a few beers! Taken at the summit of Cairngorm in the Scottish Highlands, this could also be used to represent cold, endurance, or fortitude.

Opposite: The opening of the Cottons Centre on the bank of the Thames in London, England. On the right of this picture is the building and the reason for taking the photograph. The clients were very happy with the result, and used the shot for Christmas cards and many very large wall prints. Shots of fireworks, however, could equally be used to depict practically any type of celebration.

Right: The important thing when photographing elephants is to catch them when they are agitated, with their ears out and their trunks moving; otherwise they look really static. This could be used to symbolize memory, heaviness, family, and so on. It was taken on safari in Kenya with a 300mm image-stabilizing lens, hand-held.

Be there!

It is more productive to "be there" at the decisive moment with minimal equipment, than to arrive late and miss the best shot as a result of struggling with a heavy load of equipment, or spending too long deciding what items to take. Robert Doisneau managed to take brilliant images using a Rolleiflex camera with a single fixed 75mm standard lens—he did not have a camera bag bulging at the seams, and could concentrate all his creative powers on the image at hand, rather than dithering with different lenses.

In many cases "less is more," but naturally certain subjects, such as sports and wildlife, do require the right equipment. For certain types of image, also, a tripod is quite essential. But, regardless of the equipment and how comfortable the bed is that morning, the photograph will not get taken without you.

In hurrying to get to a particular destination you must never pass by another image, saying to yourself, "I'll shoot that one on my way back," because on the way back the image is always in a different light, usually nowhere near as good, and, more often than not, gone altogether. If it is good enough to warrant the film, stop, and take it then and there. A bird in the hand is worth two in the bush, as they say. If you have

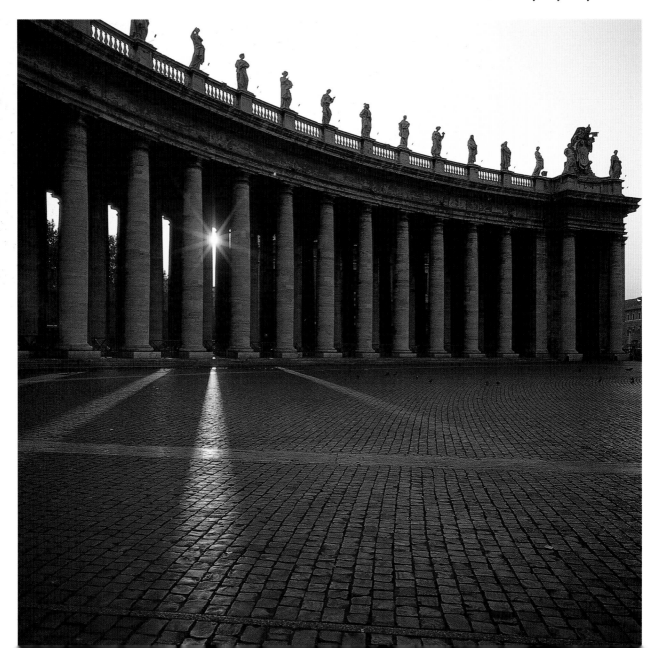

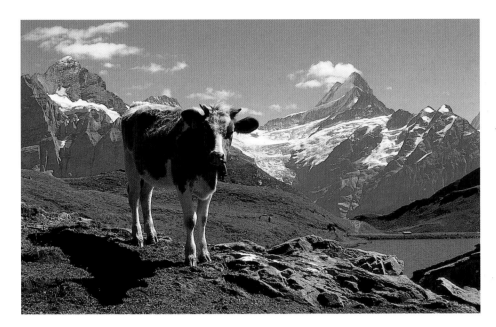

Left: A moment later this cow was plodding back downhill and there would have been an empty picture. It was taken by Bachalpsee, thousands of feet above Gridelwald, Switzerland.

Below: The Santa Fe Railroad at Flagstaff, Arizona. I shot many trains as they came through, looking for the most photogenic. Most came too slowly, so would have looked static—the blur is necessary to show movement.

Opposite: This shot of St Peter's Square, Rome, Italy, required three visits. The first time I was late and the starburst had passed. The second time I got it right, but there was a lot of tourist litter.

Above: A few minutes earlier the sun was still asleep; a few minutes later the mist had burnt off. This was the decisive moment, taken at Ardingly Reservoir, Sussex, England, where I walk the dogs.

already captured this chance image on the way out, and it is still there on the way back, then see if the light is better, and, if it is, take another shot and win again. If the light is worse or the image has gone, at least you have the earlier version in the can.

I have found that trying to find images from a moving car is a really frustrating way of working. When you see an image from the car there is inevitably nowhere to stop, and when you do find a parking place, the image you saw never looks as good as it did from the car. There really is no substitute for deciding in advance the area to which you are going, driving there, and then covering it on foot.

Image style

At the time of writing, the style of image preferred by most agencies and libraries is modern and contemporary. Their stocks are presently bulging with classical and traditional renditions, especially in the landscape and travel sectors. They are now tending to seek the imaginative and different.

Right: Position in my bestseller chart: #5. Number of sales: 53. Highest single sale: $2,058 (£1,410). Number of years since first sale: 12. My total income to date: $10,117 (£6,930). This sundial can be found on the Church of St. Dionysius in Market Harborough, Leicestershire, England. It required quite a bit of perspective correction in Photoshop because it is high up on the bell tower. I used a 400mm lens (image-stabilizing and hand-held) and got as far away as possible, but there was still considerable distortion. It has sold amazingly well, having been in several catalogs with a major library. The wording really helps to sell this image, because it portrays time and timekeeping in such a photogenic way.

The classic shot of the Eiffel Tower, for example, used to be the one taken from the Palais de Chaillot looking across the fountains to the tower. It is likely, however, that libraries and agencies have many excellent shots of this style, and what they now want is a composition perhaps from close up, looking right up and at an angle, with the French flag from a souvenir stand in the corner.

Another example might be the image of a flamenco dancer to represent Spain—the traditional approach would be to show the dancer caught in a static pose by using flash or a fast shutter speed. Today's trend would be to use a slow shutter speed and depict the dancer as blurred and twirling. Likewise, to represent a busy highway, instead of the usual lines of traffic, show the streaks of light made by their lights (as in my shot of the highway shown on p. 53, which has been sold to over 100 buyers less than three years after being taken).

The treatment of the image by using monochrome methods for certain types of image can be very effective and is currently in demand, as is the use of cross-processing techniques, such as the processing of slide film in negative film solution, and vice versa. Such darkroom trickery can also be easily mimicked in the "digital darkroom," using an image manipulation package such as Adobe Photoshop (see p. 106).

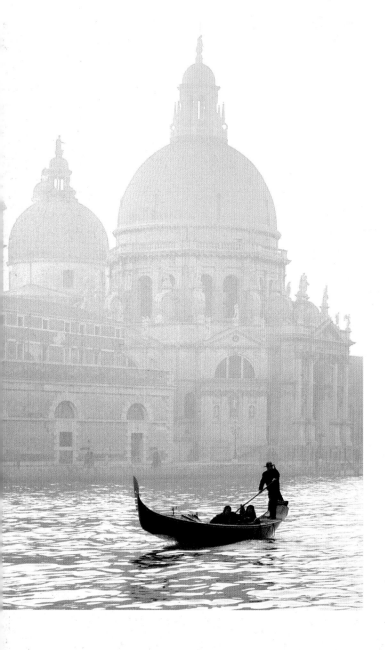

Left: Shot with Fuji Velvia on a dull, drizzly afternoon, this view of Santa Maria della Salute, Venice, Italy, was hopeless as a color rendition—but with a little help from Photoshop, I had a modern, eye-catching image.

People in pictures

People in photographs give the other features in the composition scale, and can give an image a sense of life. The image of beautiful mountains is very pleasant in itself, and may fulfill certain customers' needs, but it makes sense also to shoot the image to include some hikers so that it can be used with or without. People in pictures help the viewers to relate to that place or event, because they will subconsciously say to themselves, "I wish I was that person, there."

People who epitomize a country or event are really important for a stock collection, such as a Berber to represent the Sahara, a cowboy to represent the Midwest, or a Masai warrior to represent Kenya. Likewise, it is just as important to exclude people who contradict the scene or event, those who are quite wrongly dressed or just out of place. In stately gardens or in an Alpine meadow, for example, it would be inappropriate to include a group of bare-chested youths drinking beer. Such photographs might make for good social realism, but they won't sell through a stock library, even if the agency agrees to accept them in

Left: This sort of candid portrait is perfect as a filler on a page about the Sahara or Morocco to bring the text to life and add color. The Berber people are not keen on having their pictures taken without their permission and a reward, however small—in Marrakesh I only had to give a water carrier a couple of pieces of candy as payment.

Opposite: A hiker in the flower-filled alpine meadows, above Crans Montana in Switzerland, provides a foreground subject for the pretty backdrop. It is very useful walking with your own model!

the first place. Similarly, in an obviously summer sun scene, exclude that odd character in an anorak with the inevitable white plastic shopping bag.

Take care when selecting people to include, because any particularly fashionable clothes will quickly date, and make the image far less salable in the long run. Including tourists is very worthwhile for the travel market, because it makes the viewer really believe that he or she could be there, too. The inclusion of a group of people admiring the Grand Canyon from one of the overlooks, for example, certainly helps to give some scale to that incredibly difficult to photograph, vast, and empty scene.

However, the inclusion of people brings problems, principally the need to have properly signed model releases for each person. Most libraries and agencies will not accept a photograph that includes people who are identifiable without signed model release forms (see p. 122). Including members of the public in your pictures, and then having to ask each person to complete and sign a model release form, can be a very trying, if not embarrassing task, made far worse if

Above: A piper in a kilt with granite buildings—this could only be Scotland, and this image makes a great primary or locating shot. An image from this viewpoint, on Calton Hill, gives a pleasing shot of Edinburgh, but the piper really brings it to life.

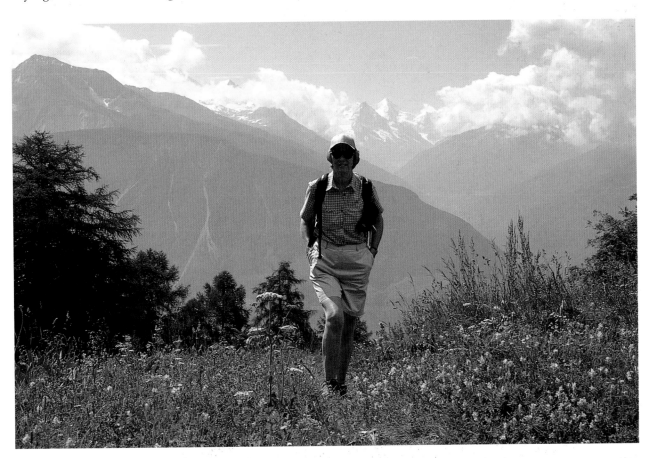

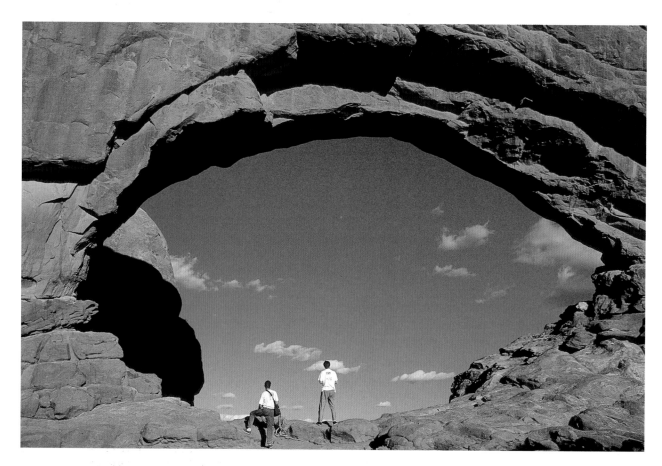

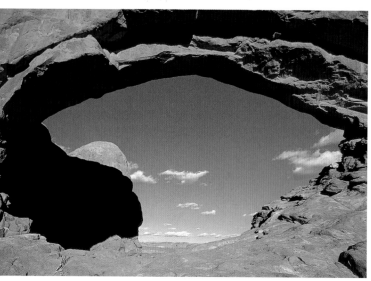

Above: These two images of South Window, Arches National Park, Utah, clearly show the impact of including people to give scale. Shoot with people and without, so the agency can offer either or both to the buyer.

unfamiliar foreign languages are concerned. When children are involved even more difficulties arise, because the model release form must contain a signature from their parent or guardian. Taking your own models is by far and away the best solution—you control their looks, dress, and position. If you use friends and family, you may in addition avoid having to pay modeling fees.

Another drawback to including people is that members of some cultures are sensitive to having their photograph taken, for religious, superstitious, or other reasons. However, it is amazing how often these inhibitions disappear if they are asked beforehand and given a financial consideration—or, in the case of children, candy.

Finally, you should beware of photographing people working at airports, military installations, and other governmental sites, because in some countries it really is forbidden. Those who didn't realize this, or who thought they could get away with it, have found themselves in jail on espionage charges.

Left: This vast expanse of subject matter needs something to give it scale, and for the travel market, what better than a group of people clearly relishing the amazing vista of the Grand Canyon?

Ways of working

There are many different ways for the photographic assignment to be undertaken:

• The solo photographer on assignment represents the most focused approach, but can be lonely, particularly if you don't speak the local language and are away for any length of time.

• Going as a group with other like-minded photographers is another possibility. The interaction with others broadens creativity, and they can act as free models. For many years I was co-organizer of mountaineering trips to the Scottish Highlands and the Pyrenees, taking photographers to places they would not be wise to attempt on their own. These trips allowed me to get images I could not have gotten to alone, and I was among like-minded fellow-travelers for the whole trip, sharing ideas and enthusiasm. The main drawback was that there was always somebody setting up a tripod in somebody else's picture!

• Traveling with a group of non-photographers, whether family or friends, can be extremely frustrating. They never want to stop where you do, will not wait, and inevitably want to go elsewhere. However, if you are very disciplined you can take your pictures early or late in the day, alone. Then you can enjoy the others' company during the less photographically rewarding parts of the day. With the offer of a drink, or similar "bribe," you will also be able to use your friends and relatives as unpaid models.

Left: A very pleasing shot of the landscape at Creag Meagaidh, Scotland, but it would have been quite "empty" without the hikers. It takes a lot of effort to keep running ahead, and uphill, of one's companions to get the images, but the picture is all the better for it.

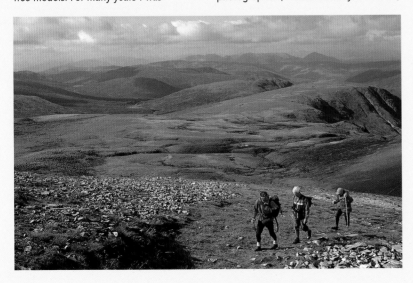

Subjects not to overlook

Having been a stock photographer for over 20 years, I know that it is almost impossible to predict which of my pictures will be the most financially rewarding. Again and again, seemingly simple shots that I have captured on my travels have made me hundreds, if not thousands, of dollars. We have already looked at some of the more obvious subjects—the landmarks, people, and so on, that typify a location—but there are plenty of other incidental scenes that can be turned into profitable pictures.

Statues of famous people, for instance, can prove successful, particularly if they were alive before photography was invented. Every major city has an abundance of such sculptures.

Street and location signs are another area that can prove very profitable. Imagine that a picture buyer wants to illustrate the New York Stock Market—a simple shot of a sign saying "Wall Street" would do the job very nicely. Similarly painted advertising signs, such as those found on the sides of buildings in France for Cinzano or Pernod, can also be good sellers.

Above: While waiting at Flagstaff, Arizona, for the train pictured on p. 71, I turned around, and behind me was this sign, which is a really typical filler picture for an editorial.

Left: Timbuktu, or Tombouctou as the French write it, is synonymous with the desert and travel to remote places. A more photogenic sign for the town would be difficult to find —this image alone paid for a three-week camping trip to Morocco. The sign is in Zagora on the edge of the Sahara.

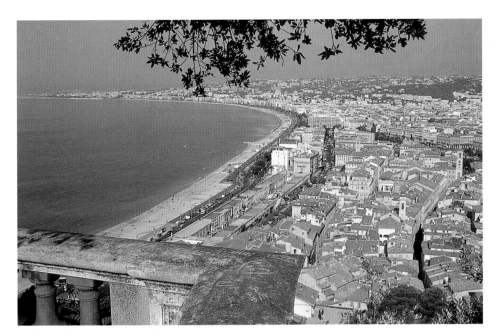

Left: Panoramas of cities are always on libraries' "wants lists," because they are true locating shots. This view of Nice, France, was taken from the steps going up to the old castle.

Below: This view from Piazzale Michelangelo in Florence, Italy, has been very rewarding for me. The shot shows the River Arno snaking through the city, with the Ponte Vecchio in the foreground. With the sunset, the image has much to tempt picture buyers.

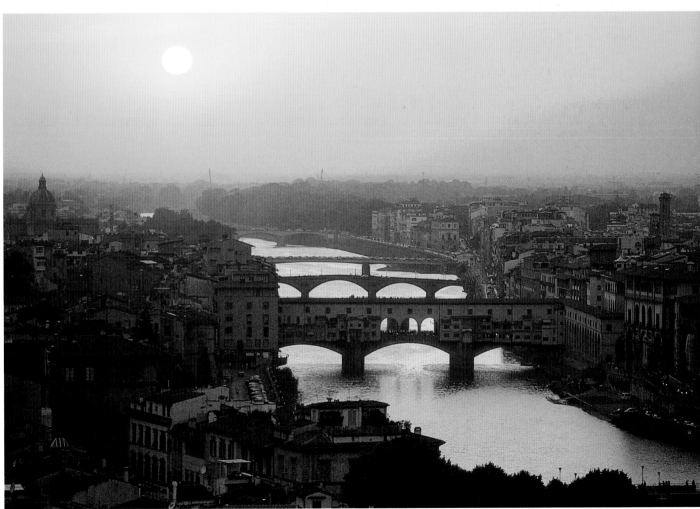

Below: During my stay in Vienna, Austria, this statue of composer Johann Strauss, found in Stadtpark, was being gilded. Originally it was a dull stone color, proving that sometimes one needs to be lucky. In its new livery the picture has sold really well.

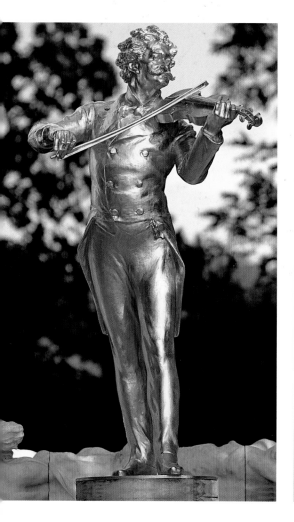

Left: Another easy-to-take image that has already easily paid for the trip on which it was taken. The statue shows Romulus and Remus—brothers who, legend has it, were nursed by wolves as babies and then went on to found Rome. It has been used to illustrate Roman history. Located in Siena, Italy, by the Duomo, it was shot with a 400mm image-stabilizing lens hand-held.

Above: Averroes was a famous medieval Moorish philosopher, and this shot has sold many times to illustrate the historical background of southern Spain. This statue is found outside the Alcazar Gardens in Cordoba, and this image paid for a two-week trip around Andalusia.

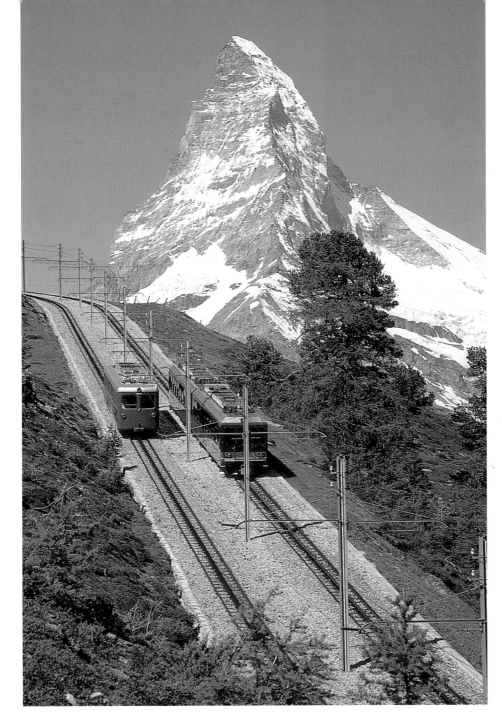

Left: On the first day in Zermatt, Switzerland, I found that this image was used many times on local guides, brochures, and so on. We found the location, and I made my own version. This is the train that runs from Zermatt town to Gornergrat at 10,270ft (3,130m) up.

Above: An image does not have to be from a faraway, exotic place to sell. My neighbor's daughter was getting married, so I shot this generic image of the wedding car and its ribbon—another useful filler for editorial use.

Right: Grand building that the Vienna Opera is, one has to admit that it is a bit dull on its own. The inclusion of the tram as the subject makes the Opera a really good background. This is no prize winner, but has proved a steady earner.

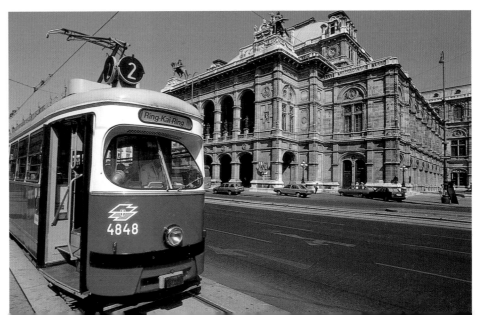

Taking the photograph

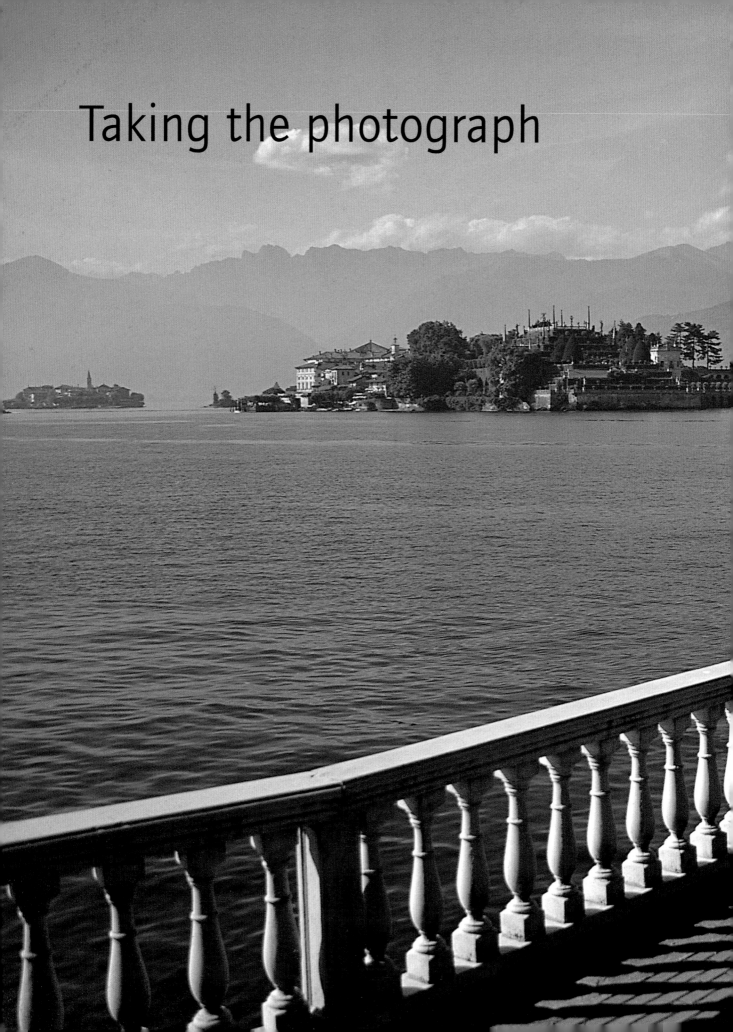

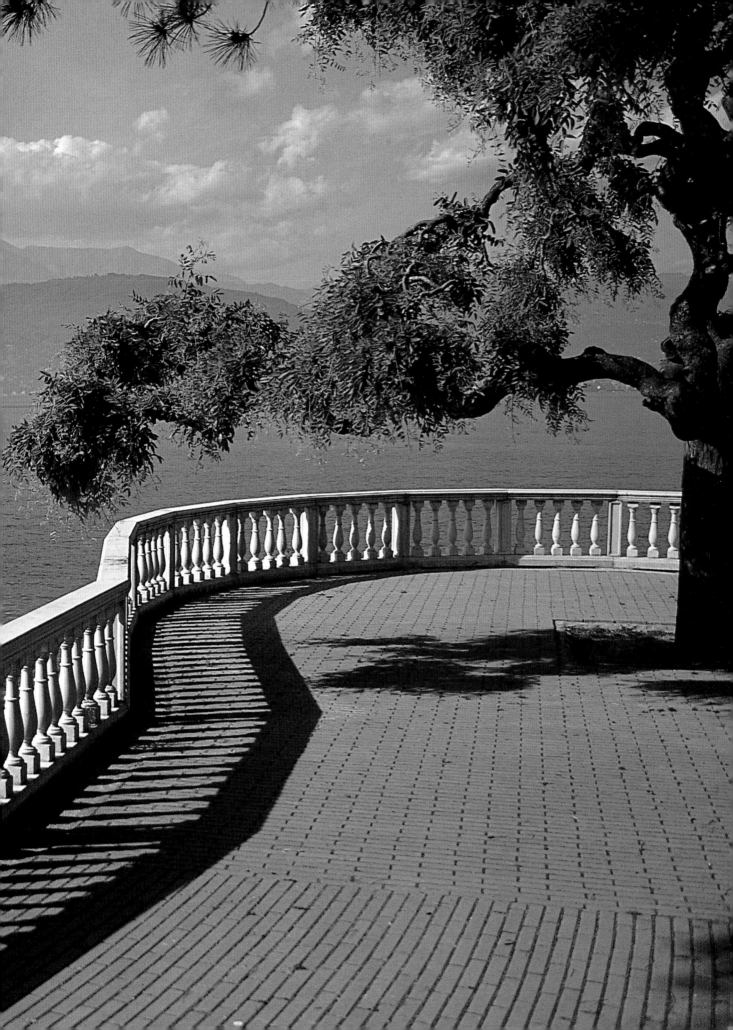

Quality matters

In stock photography image quality is absolutely essential, and the libraries and agencies demand the highest standards. The reason is simple—they do not know when they choose the image what size the customer will want to use. If all of their customers never printed larger than Letter or A4 size, then they would not need to demand such high quality. But some pictures get blown up much bigger. Many of my images have been enlarged by buyers to 4ft (1.2m) across, and one of my shots, still hanging in a bank's atrium, is 6x6ft (1.8x1.8m). To retain quality at that size, the original must be absolutely perfect, razor-sharp, and grain-free.

Right: On the summit of Cairngorm in the Scottish Highlands this group walked past us. This sharp—from front to back, hand-held grab shot with a Nikon F4 was achieved because my 35mm lens is always set to $f/11$ and focused at the hyperfocal distance, so I am ready for the decisive moment. Sold to 24 different buyers for all manner of purposes, including a postcard, this image has earned me over $3,650 (£2,500) so far.

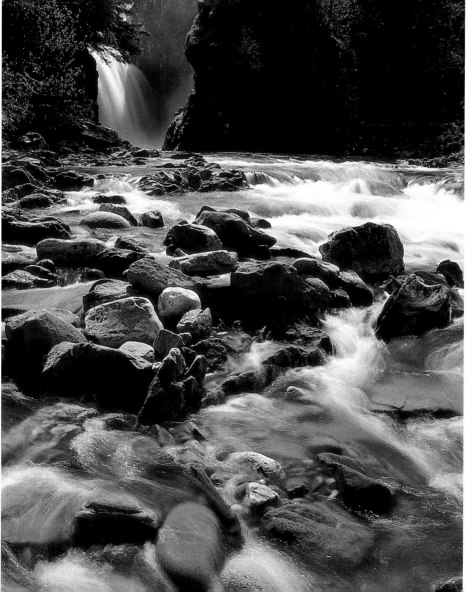

Left: Critically sharp from front to back—as it should be—this image was achieved by manually setting the lens to the hyperfocal distance at Pattack Falls, near Loch Laggan, Scotland. I used an all-manual Leica R6 with prime lenses and a carbon-fiber Gitzo tripod.

Opposite: A different view of the Vatican and St. Peter's Square in Rome, Italy, showing, perhaps, the "strength of the church." Sharp in all planes, it was taken with a Hasselblad on a Gitzo tripod at the crack of dawn.

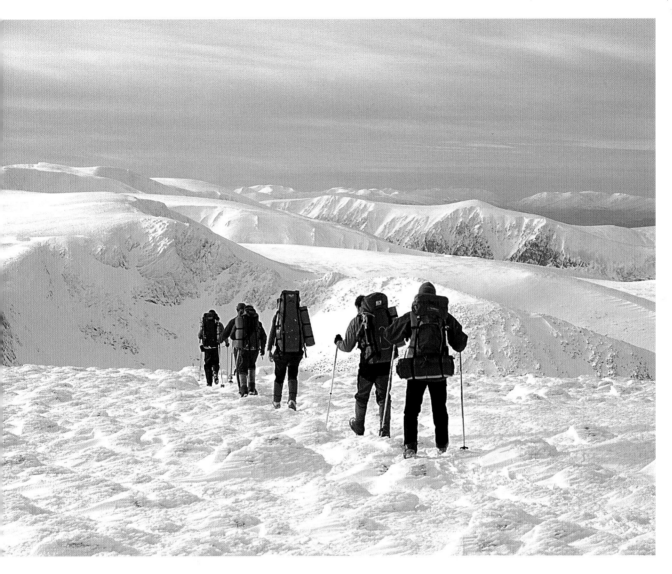

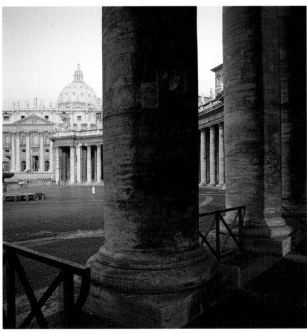

In addition to sharpness and lack of grain (unless blur or grain are an intentional feature of the image), it is also essential that the exposure be perfect—there must be detail in the highlights, and detail in the shadows. Beware of large areas of bright sky, because this can affect the automatic meters on some cameras, a risk especially common when using wide-angle lenses and resulting in the rest of the image being severely underexposed.

The colors must be well-saturated, and the composition balanced and eye-catching. In some cases, it is appropriate to compose the image, or at least some of the variations that you shoot, so as to leave space for the buyer to put in text, even though this will inevitably make the base composition unbalanced (see p. 93).

In short, the image has to be perfect in all aspects if it is to compete in today's market.

Ensuring maximum sharpness

I am often asked how I ensure that every element in an image is sharp from close up to the horizon. There are two ways to accomplish overall sharpness—by manual calculation, or by using a camera with a proper depth-of-field program.

With a manual-focus camera and a non-zoom lens, the solution is simple:

- Select the aperture required for the exposure, say *f*/8.
- Set the ∞ mark on the focusing ring to coincide with *f*/8 on the depth-of-field scale on the lens barrel.
- Set the other *f*/8 mark on this scale ring against a distance—everything will be sharp from this distance (the hyperfocal distance) to infinity.
- To get more of the image sharp, go back to the first step, but use a smaller aperture, say *f*/22.

Naturally, you need not only use the ∞ setting—the first aperture mark can be set to any distance, and then the plane of sharpness will be between that distance and the other distance shown against the second aperture mark.

Left: On the summit of Klein Matterhorn, high above Zermatt, Switzerland, we are 14,000ft (4256m) up. In spite of puffing hard in the rarefied air, I managed to get it all sharp, from the cross to the Breithorn in the distance, which we had just climbed. I used a Leica R6 with a 21mm lens.

Right: There is considerable depth in this image of the Piazza Navona, Rome, Italy, and it all must be sharp and crisp. It was difficult to avoid heavy shadows because later, when the light is better for these shadows, the square is swarming with tourists. Shot with a Hasselblad and tripod.

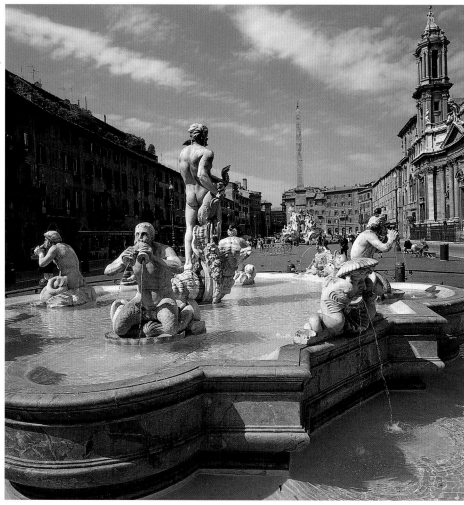

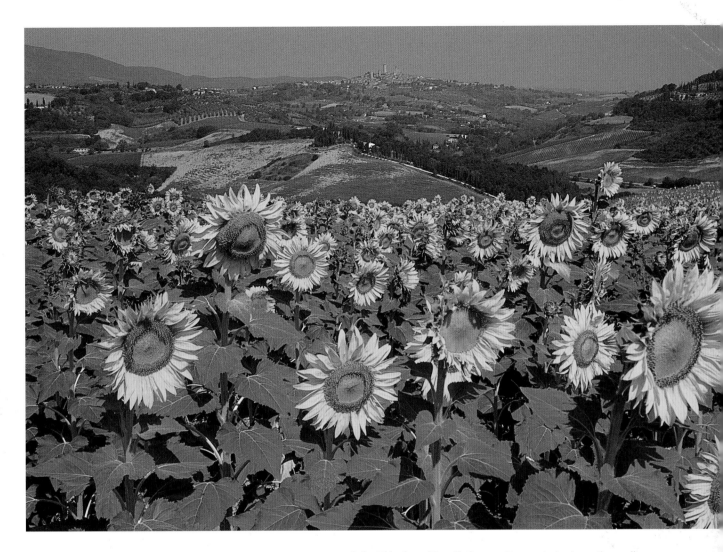

Zoom lenses make this method nearly impossible, because they generally do not have depth-of-field markings for every focal length, if they have them at all.

Whenever I use manual cameras, I make sure that I always keep the aperture set at $f/11$ and the ∞ mark set to $f/11$ on the depth-of-field scale. This means that I am always ready for rapidly changing opportunities and events.

Some modern autofocus SLRs offer a depth-of-field program that makes the whole process of maximizing depth of field much easier. These systems use the autofocusing system of the camera to measure the distance of the farthest and nearest subjects in the frame, and then calculate the necessary aperture, while setting the focus to the optimum distance to achieve the maximum depth.

On some models you can select these farthest and nearest points manually—on others with multi-point autofocus, the whole process can be automated. Be forewarned, however, that some depth programs use a far inferior method for maximizing depth of field,

Right: This view of San Gimignano, Tuscany, Italy, shows the quality of a modern zoom lens—even at the minimum aperture of $f/22$ those petals are sharp enough to cut your finger, and the distance is razor-sharp too. I used a Canon EOS hand-held with a depth-of-field program and a 28–135mm image-stabilizing zoom lens.

simply setting the smallest aperture possible for a shake-free, hand-held shot and not adjusting the focus.

There are, of course, many subjects and images where you don't need, or even want, to have everything in sharp focus. Portraits and sports images are the prime examples where you will frequently strive to ensure that only the subject is sharp, and that distracting backgrounds (and foregrounds) are made as unrecognizable as possible.

You have to select the relevant plane of focus for that image by focusing on the main feature—for any portrait, this should be the eyes. Then you select a large aperture, but not one so large that other features of the subject are not sharp.

Bracketing exposures

Shooting on slow transparency film demands very accurate metering—the latitude with Fuji Velvia is only ⅓ stop. Unless you feel confident that you can meter a scene to this accuracy, you should take additional shots at different settings, bracketing the exposures to ensure getting one that is perfectly exposed. A number of modern SLRs will take this bracketed sequence for you automatically.

I abhor this waste of film, and hardly ever bracket exposures. I believe that if we are good enough to sell our images then we should be good enough to get the fundamentals of photography right every time.

With completely manual cameras, and using a hand-held meter, it is not difficult to get perfect exposures once you are well-practiced at the technique. With the modern automatic cameras that offer so many different exposure methods, including "intelligent" options such as matrix and evaluative metering modes, there really is no excuse for not getting perfect exposures every time.

Nevertheless, there are times when bracketing is essential, particularly when shooting at night and other long exposures. Because of the low light level, the exposure necessary for night shots must be very long, and this affects the sensitivity of the film. The long exposure induces "reciprocity failure," for which you must make allowance by making the exposure even longer than the meter suggests (there are tables of data for each film type showing the extra allowance that must be made for each second of long exposure). For buildings after dark, and for other shots with exposures over 1sec, such as fireworks, it makes sense to bracket the exposures considerably.

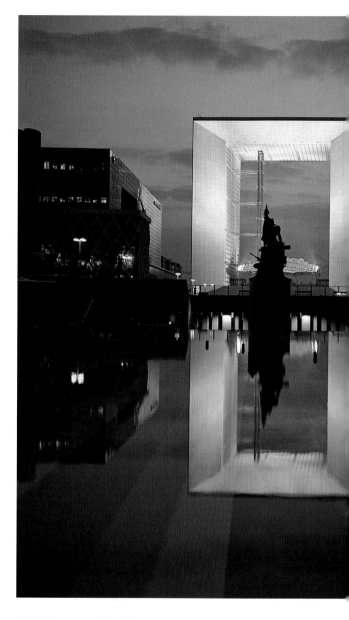

Above: The Grande Arche, Paris, France, is a typical night shot that really does need bracketing to ensure that you have a choice of exposures. The reciprocity failure that occurs with long exposures can also change the color balance of the image; additional filters can be added to correct the color.

Right: Shot from my hotel window in Frankfurt, Germany, bracketed for a selection of different exposures from which to choose the best.

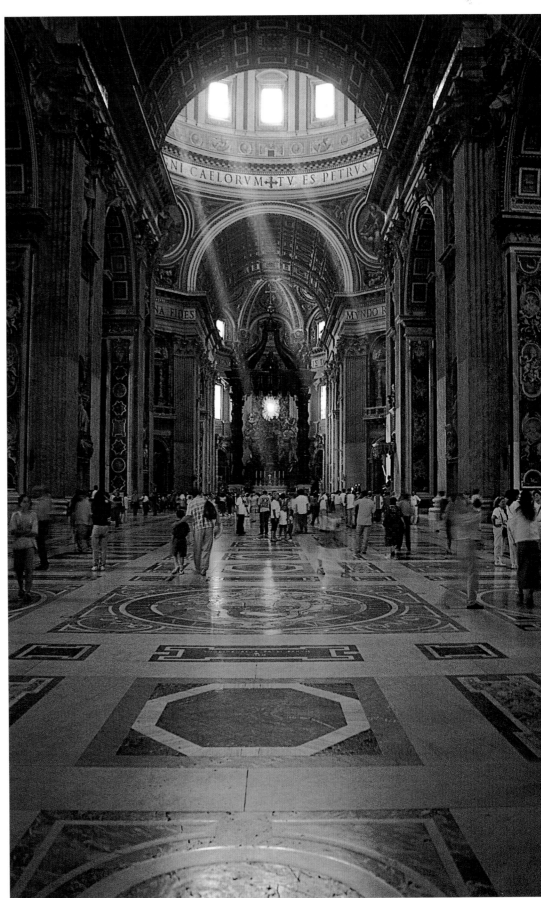

Right: The interior of St. Peter's in the Vatican, Rome, Italy. I didn't take a tripod in here, because I assumed it would not be allowed. However, it is amazing what can be done with image-stabilizing lenses—this is hand-held, and due to the incredibly low light I took several shots in the hope that one would be sharp. In fact, several were.

Getting the light right

Choose the right time of day for the appropriate light for each shot. Early morning, directional light can be quite wrong in a city, because buildings could well cast deep shadows on each other. It is probably better when the sun is higher—this will mean that light gets into the "canyons" between the buildings. But for a landscape, shooting at midday when the sun is overhead is likely to give a very much less interesting shot than at either end of the day, when the light is more directional and enhances the features in the composition.

If the light is not perfect, it really is not worth pressing the shutter and spending money on film and processing. The hope that the library will take the shot just because that was the best light you had is forlorn—the library will most likely already have a very similar shot from another photographer but in perfect light—and given the choice, which is the image buyer going to want?

Night shots should be done when there is still some tone and color in the sky; so it is usually best to shoot pictures within the hour after sunset (or sometimes less than an hour before sunrise). Outside these times the sky appears just black in your pictures, giving no interest in the sky, and no depth to the image.

Above: Night lighting and illuminations on buildings quite often make for a more attractive image than daylight, but it is very important to shoot when there is still plenty of color and texture left in the sky. I have found that night shots sell well, such as this one of Nôtre Dame, Paris, France.

Left: The light on the stones and the snowy mountain give this image of Castlerigg, Keswick, Cumbria, England, its appeal. Shot an hour later, this pleasant modeling light would have been too high.

Above: Light is the most important ingredient of a photograph—the more interesting the light, the more exciting the image. In this view of Derwent Water, Lake District, England, an early morning directional light catches all the important picture elements, and even turns the row of trees into silhouettes.

Left: The lighting helps to give relief to the Grand Canyon, showing its size and making the lone figure stand out. It is useful to travel with someone who has a head for heights!

Composition

I n order to get the picture buyer to select your image, it must stand out from those in the library taken by other photographers. To do this there must be something special about that image—the lighting is probably the most important thing, but the composition is also fundamental.

You must ensure that all the elements of the composition are arranged to give greatest impact; there is little merit in having all the right ingredients, but no recipe. If there is foreground interest, make sure that it is really seen well, and not just incidental. Get the horizon level—there is nothing more annoying than seeing the sea or a lake pouring out of an image.

Crop tight to give impact, but, just as important, do the exact opposite for an alternate shot—give lots of space around so the buyer can crop as he or she wants. Deliberately including large blank areas of sky, for example, will allow users to overlay text. If you do not give the publisher room for his or her text, he or she will surely find a way to spoil your image and put text and all sorts of things just where you would think it impossible!

The composition and the lighting are the picture—unless these being well executed, there is little hope that the library will select it, and even less chance of someone buying it.

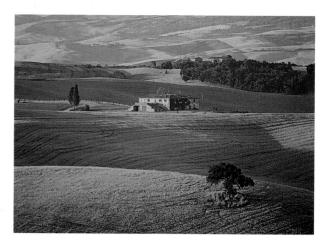

Above: The compositional elements of this image, near Pienza, Tuscany, Italy—the foreground tree, the farmhouse, and the distant fields—need to be arranged to please the eye; but the light is fundamental to the composition. The image was really composed around the lighting effects—10 minutes later, there was no picture.

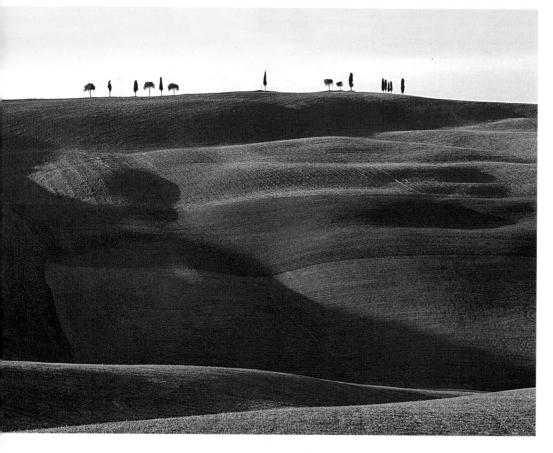

Left: Composition is nearly as important as the lighting—the eye must be immediately drawn to the subject. The eye is usually first drawn to the lightest part of the image, here the skyline trees near San Quirico d'Orcia, Tuscany, Italy.

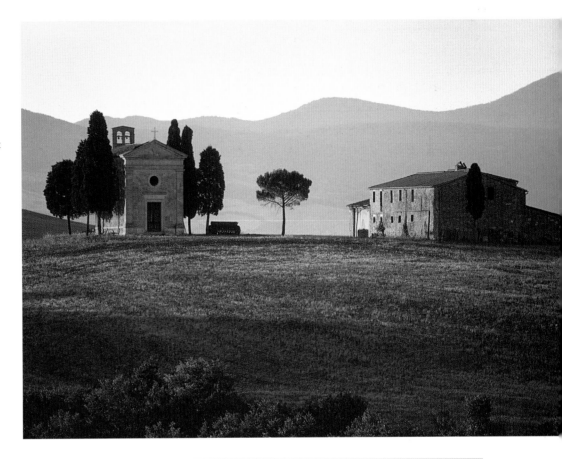

Right: The eye is immediately drawn to the attractive, early morning light playing on this chapel and barn near Pienza, Tuscany, Italy. The arrangement of the buildings and fields is important, but the light is also a fundamental element of this composition.

Balance and space

The viewpoint you choose is fundamental to the success of the resulting image; in all three of the images on pp. 92 and 93 if I had moved my camera position 50 yards (46m) or even feet (15m), to either the left or right the images would have become unbalanced, or important compositional elements would have been lost.

With the first picture the foreground tree would have not balanced the farmhouse.

In the second picture the foreground rolling fields would not form overlapping triangles, and in the image on this page the attractive lighting on the side of the buildings would have been lost.

Right My photograph is almost lost in this advertisement. The base image was the one on p. 38. I did not consciously leave space for text (it was too cold and windy to think of anything but getting the image), but the clients recomposed for their own purposes.

Right The value of composing the image to leave space for text is quite clear from this image. From the photographer's artistic view, the image is spoiled, but it is selling well, time and time again. The image, however, must be strong to start with.

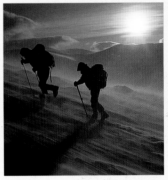

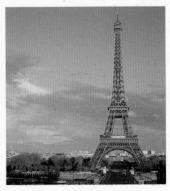

Framing

aving found the image you want, and having established the best viewpoint, it is wise to then try to find acceptable alternative viewpoints that will provide images that are "dissimilar," and can therefore be sent to multiple agencies. Likewise, changing the framing from horizontal to vertical, and a change of viewpoint will give more varied images. The inclusion, or omission, of a significant foreground element can also differentiate one image from another.

Horizons must be horizontal, unless you intend the composition to be slanted. In addition, it is not necessary to stick to horizontal and vertical formats—some architecture, people, and statues look really great from all sorts of different angles.

It really improves a composition to try to find objects that can frame a picture—this helps to draw the eye to the subject. Typical framing objects are trees and buildings, but anything can be used, from yachts to coils of rope.

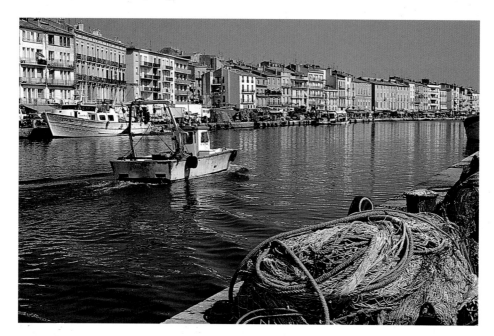

Left: Taken in Le Grau du Roi, in the Camargue area of the South of France, this image is very typical of the coastal towns and villages, and is a steady seller to the travel industry. The framing of the coiled rope in the foreground is the key to the success of this image—without this, it would be very ordinary.

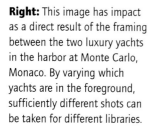

Right: This image has impact as a direct result of the framing between the two luxury yachts in the harbor at Monte Carlo, Monaco. By varying which yachts are in the foreground, sufficiently different shots can be taken for different libraries.

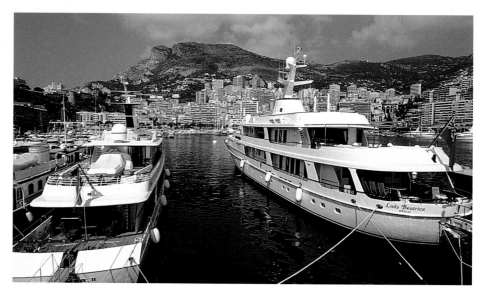

Above: The posts help frame the picture elements, while the gondolas pointing at San Giorgio, Venice, Italy, give the eye direction.

Left and above: Monument to the "discoverers" in Lisbon, Portugal. Shoot both landscape and portrait formats, and then the buyer can choose.

Selecting the focal length

There is a great tendency when shooting landscapes, architecture, and cities to use the widest angle lens to "get the most in." There is no doubt that this can produce a very effective image, but you should not overlook the opportunities from this viewpoint that can be achieved by changing focal length, therefore giving many different images that can be used as non-similars.

There are also many occasions when a landscape scene can be made very much more dramatic by using a longer focal-length lens, and selecting a small area of the scene, or just one component. In photographing mountains, especially when high up among the summits, the use of a wide-angle lens can tend to diminish the drama and scale of the huge peaks simply because to get so much in the frame, the lens has had to make the mountains smaller. Naturally, when in such a location you should shoot the wide-

Above: If I had used a wider-angle lens, the two figures would have been quite lost. This focal length keeps the drama of the scene, and gives just enough breadth to show the expanse of the mountain range. I am standing on the summit of the Breithorn in the Swiss Alps, looking back at my tracks.

Left: A 50mm lens was used to retain the scale of the mountains behind the climbers at Cirque de Gavarnie in the French Pyrenees.

angle panorama, but do not waste the opportunity to change focal length and select smaller areas. In fact, using a standard focal-length lens (50mm for 35mm cameras, 80–105mm for medium format), or even a short telephoto lens, will often retain the drama of the scene far better than a wider-angle lens.

But having managed to get to the viewpoint and given the opportunity, always shoot the scene using all variations of wide-angle lenses, telephoto lenses, and vertical and horizontal formats to give different images for submission.

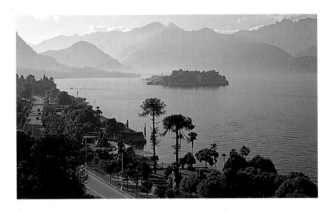

Below: I used a 28mm lens to compose this image. It does give drama to the climbers descending the ridge of Aiguille de Midi high above Chamonix, towards Mont Blanc in France, but it has clearly diminished the scale of the mountains in the background.

Above right: From the rooftop of a hotel with a 70mm lens; this retains the Isola Bella on Lake Maggiore, Italy at a reasonable size.

Right: A wide-angle lens emphasizes the balustrade and frames the Isola Bella.

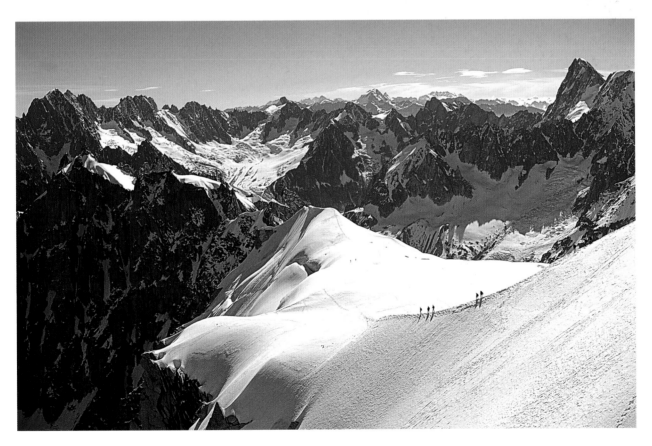

Hostile elements

Dust, water (and all other liquids, including beer and coffee), heat, cold, sun, snow, ice, and humidity are all enemies of cameras and film. The photo-grapher, therefore, must take precautions to minimize the risks of these elements, and this is especially true for location photographers.

The sand storms in desert regions produce a dust as fine as talcum powder that will get into everything unless it is well sealed. In a sandstorm in Morocco I put all my equipment, including the bags, into plastic garbage sacks; even so, there was still some sand in the bottom of the bag. Always keep roll film in a dust-proof plastic bag, and always ensure 35mm films are stored in their plastic canisters.

Water is a particular peril when hiking in the mountains, so I always carry a plastic sack, so that if it really rains hard I can put the whole camera bag in the sack inside my rucksack. I have done this since having been badly caught out on a trip to the Isle of Skye—it had started to rain, so I put my camera bag in the rucksack, but when I arrived at my car I dis-covered that the rain had penetrated right through into the camera bag. That's Scottish Highlands rain for you!

Cameras can tolerate reasonable heat quite well, but film deteriorates as the temperature rises. Extreme cold can be even more problematic. Below freezing, film hardens and is more difficult to wind around the spool—this is especially noticeable with some medium-format cameras. The most common problem

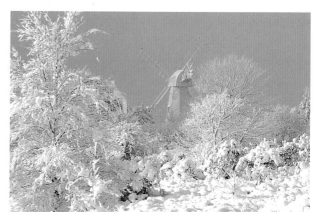

Left: The spray rising from the waterfall was more penetrating than a heavy shower of rain. I used a UV filter to protect the front lens element—I could keep wiping it dry—and of course a lens hood to give as much shelter as possible to the lens. The Pattack Falls, near Loch Laggan, Scotland, were shot with medium format.

Above: Batteries run down very quickly in the cold, so always keep spares warm in your inside pockets. When changing film in deep snow try not to drop a roll—it disappears without trace, as I know to my cost! This was shot in Sussex, England.

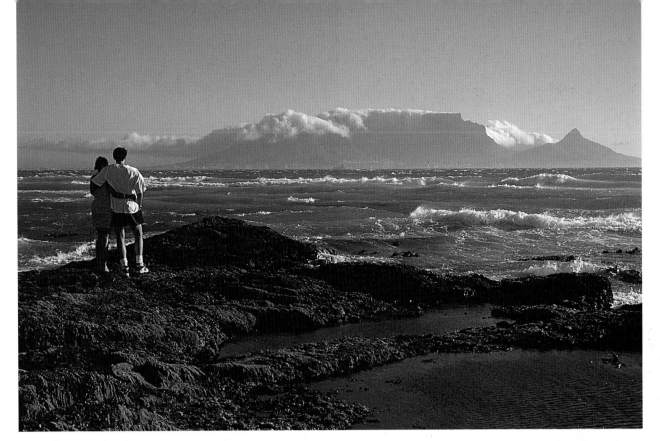

Above: This scene, Table Bay from Bergstrand, Cape Town, South Africa, might not look dangerous to the camera, but it was really windy, blowing the sand from the long beach and the salty sea spray right on to the front lens element—zoom lens mechanisms do not like sand!

Right: It was raining steadily at Langstrath, Lake District, England, and the spray in the wind from the cascade made this a very hostile place for the delicate mechanisms of modern electronic cameras. Instead of risking my main camera, I used a compact camera with manual controls for overall sharpness.

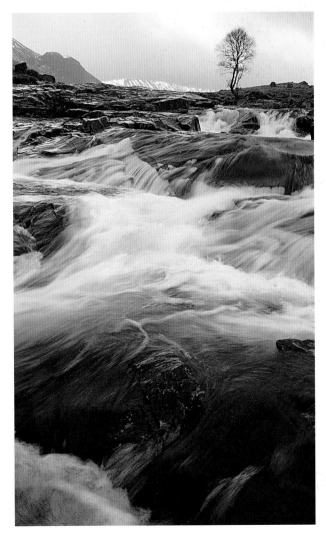

these days, when we rely on electronics so much, is the deterioration of batteries at low temperature. When shooting winter scenes, or just high in the mountains, keep two or three new spare batteries in an inside pocket to benefit from your body warmth; make sure the spare batteries are new, because old ones deteriorate even more quickly than new ones.

Humidity is a really difficult element to combat—condensation can get right inside the lens and mist it up from the inside, and it usually takes forever to clear. This can occur most easily when you come in from a day in below-freezing temperatures, and the equipment is really cold right through, into a warm room. The best way to avoid condensation is to leave the cold equipment in the bag in a cooler room for an hour or two, to let it warm up slowly. If condensation has got right into the lens, put it in a warm dry place, such as an airing cupboard, for a day or two.

Post-production

Captioning and keywording

Captioning is crucial to the sales success of an image. Some big libraries have well over 60 million images, and without good captions and keywords, the image may never be found. Searching the text that accompanies an image is by far the most efficient way to retrieve images, particularly when using a library's website. The keywording is usually done by the library, although some internet-only libraries expect the photographer to keyword his or her own images.

NT001500

Keywords and Descriptors

Search for similar images using the following keywords:

☐ Cathedrals	☐ Bell towers
☐ Churches	☐ Spiritual and religious features
☐ minster	☐ Communication features
☐ Towers	☐ belfry
☐ campanile	☐ Cathedral of Pisa
☐ Leaning Tower of Pisa	☐ Pisa
☐ Pisa Province	☐ Tuscany
☐ Italy	☐ Europe
☐ Duomo di Pisa	☐ Torre Pendente di Pisa
☐ Exterior	☐ Generic persons
☐ human	☐ Christianity
☐ Many	☐ Architecture
☐ Religion	☐ Italian (origin, period, or style)
☐ Romanesque (origin, period, or style)	

SEARCH

See Restrictions

Above: To appreciate what is involved in "keywording" it is a good idea to log on to an internet site and look at the words they have selected for a certain image. Here are the keywords for the leaning tower of Pisa in Italy.

Storing slides

Transparencies need to be stored very carefully to preserve their value—a scratched original cannot be sent to a library. Each transparency should be put in its own unique, close-fitting polyester sleeve to safeguard against finger marks, scratches, and dust.

The most easily constructed filing system is the filing cabinet system where the original images are slipped into polyester sheets of pockets—a sheet will hold 24 35mm images, 15 6x6 images, 10 6x9s, or four 5x4s. A single drawer of a filing cabinet will accommodate at least 250 sheets of transparencies, a total of 24,000 35mm images in a standard four-drawer cabinet.

Some polyester filing pages have pockets for images, and an additional flap with a pocket large enough for a Letter/A4-size sheet of captions. The image is doubly protected in its own sleeve and pocket, and its caption is on the accompanying sheet.

Even the way slides are mounted can be important. I used to use Fuji's own processing laboratory, but they attached 35mm slides to the plastic mount with adhesive. One library asked me not to use these mounts, because the glue is so difficult to remove from the slide. These slides are also more prone to curvature, and show fluctuations in sharpness when scanned. I therefore now use a laboratory that does not use adhesive to fix the slide to the mount; this produces a more evenly sharp scan, and keeps the library happy.

The caption must be specific and complete—it is no good saying "landscape scene." You have to think of how the picture researcher will try to find what he or she wants. So a "landscape" caption should read: "Stone farmhouse and fields in spring at dawn in Tuscany near Siena, Italy, 1999." The image will then be found if the researchers enter any one of the significant words in the caption.

For objects and buildings, you should be equally complete, including the full name of the building and its location, for example, "Statue, marble sculpture of David by Michelangelo, Academia Museum, Florence, Tuscany, Italy, 1998." It is always helpful to add the area, county, district, and so on wherever you can. The date can also be essential—some buyers need assurance that the picture isn't decades old.

With animals and plants it is always best to give a full "common" name, and to include the scientific name if known—for example, "fox terrier" (not just "dog") or "European eagle owl, *Bubo bubo*." A location for such pictures is also advisable—every word you supply in the caption can help to make a sale.

In addition to the specific information, you can help the researchers by adding concept or theme

descriptions such as: power, love, teamwork, victory, achievement (see pp. 64–9). Keywords are simply words in addition to the caption to help the image be found—for example, with the shot of cheetahs hunting (see p. 65), in addition to the full caption of "What, where, and how?" you could add: safari, big game, big five, spots, spotted, dappled, cat, big cat, *Acinonyx jubatus*, teamwork, and so on.

Top: Having logged on to this internet site, I first searched using "rubbish," and I received 128 images. Then I searched using "rubbish Vienna," and found just this one.

Above: If I search using just the word "sunset" I get 999 images; this is no surprise for such a generic word—but if I add the word "Sussex" the selection goes down to 17—this clearly demonstrates the need for careful keywording.

Creating digital images

Transparencies and prints have been the medium for providing images to customers for many years, but now they are not alone. More and more buyers want to receive their pictures in digital form, and soon this will be the norm.

Digital files can be created using a digital camera, flatbed scanner, or film scanner. The pace of change in this area means that equipment soon becomes obsolete. Nonetheless, it is probably fair to say that the digital back on larger-format cameras will give the highest degree of detail, but these are primarily designed for studio use. The next level of quality is probably the drum scanner—these are very expensive to buy, and even having your images scanned on one of these machines by a bureau can be costly. Last, there are 35mm and medium-format film scanners that scan at a resolution of 4,000dpi; these give a file of about 55MB (for 35mm), which is more than

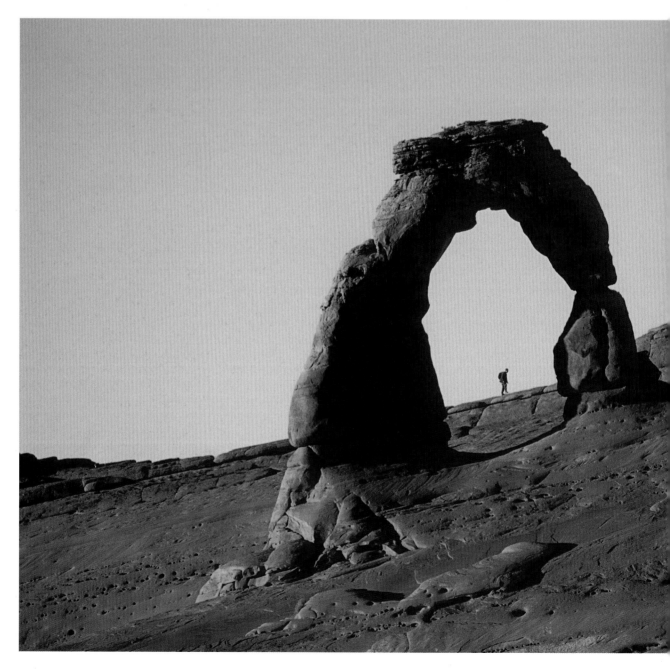

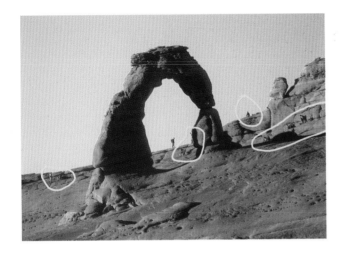

Above: Before: Too many tourists confuse this picture—especially the one in the arch on the right at Delicate Arch, Utah. You can wait until the people get into better positions, but you risk losing the light, and the picture. These people were all waiting for sunset, so they were not going to move until it was dark.

Left: After: The unwanted people have been removed, leaving the dominant person in the middle of the arch to give the picture scale and life.

acceptable for commercial stock photography. These scanners are relatively affordable, and if you do not have one yourself, a bureau will be able to put the images you want on to CD using one of these.

Calibration and workspace

It is essential that you calibrate your computer in the same way as your library does, otherwise the image that you see on your screen could well look very different on their screens.

First, it is imperative to calibrate your scanner or digital input device, or the service you use, to your computer and its screen, and then to your printer. In setting up such a system, you must create an ICC (International Color Consortium) profile that can then enable the file to be used the way you would like it to be used. This system of calibration is still not perfect, but it is the best solution available to ensure that images are displayed in the colors you expect. Most scanning equipment produces a file in RGB (Red, Green, Blue), monitors display in RGB, and most output devices such as printers use CMYK (Cyan, Magenta, Yellow, Black) in order to provide the color separations used in printing.

In recent versions of Adobe Photoshop, the RGB workspace is now independent of the system or monitor. The monitor profile interprets how the RGB data is displayed on your monitor, while the actual RGB you are editing in can be a recognized standard space, such as Adobe RGB or ColorMatch RGB. All that has to be done is to calibrate your monitor using Adobe Gamma to generate a profile description of the viewing monitor. Photoshop will then read the information from the workspace, and display it correctly.

File formats and sizes

There are really only two formats for general use, JPEG (Joint Photographic Experts Group) and TIFF (Tagged Image File Format). JPEG is a compression system that makes the image smaller and thus better to send over the internet—but smaller means an irretrievable loss of detail, so this is not the file format in which to store your high-resolution images.

Instead, they should be stored as TIFFs, so there is no detail loss, however many times they are saved and retrieved. Both Macs and PCs can read both formats. Mac users should keep all file names to eight characters or less and include the file extension, e.g. tiff, so that Mac files can be read on a PC without change.

The four agencies with which I work ask for the file size to be between 48MB and 70MB, and that the file should not be compressed, with no layers, masks or alpha channels and should be in TIFF format.

Digital manipulation

The kind of digital manipulation that the stock photographer will find the most useful can achieve subtle types of changes that make preferably invisible alterations to the image.

All manner of damage to a transparency or negative can be rectified with relative ease. Hairline scratches are the most common and present no problems at all. The secret is to choose the right brush size for the scratch thickness, and to use an area to clone from as near to the scratch as possible, specially in plain tones, such as skies, which are varying in tone along the scratch's length. Big drying or chemical marks are more of a challenge, particularly in plain tones, and may require the whole area to be replaced from a layer made from another area of the image, and then color- and density-corrected.

Density and color

It is important to ensure that the image has the appropriate white point and black point—it is better not to take the white point beyond 248 and the black beyond 5. After this fundamental adjustment, it may be necessary to lighten or darken the whole image, or part of it, using Curves. You must be careful in this process not to lose the contrast.

Color is a very subjective thing, and it is quite impossible to say that a sunrise, for example, is the wrong color, or a blue sky is the wrong blue; having said that, certain shades of blue just do not look right for sky, and certain shades of pink do not look right for skin tones. With Photoshop, you can change the color cast of the whole picture, or just a few selective areas. Changing the color cast of the whole image can

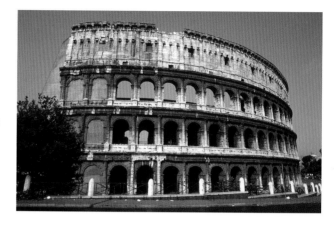

Above: Before: This image, of the Coliseum in Rome, Italy, is spoiled, and is probably not salable, because of the unattractive garbage on the pavement, and the significantly converging verticals.

Right: After: Here, the verticals have been partially corrected, because this looks more realistic than full correction. The garbage has been digitally removed, and a little more sunlight has been added.

Digital storage

The most convenient storage medium is the CD, which is really cheap, and which everyone can read; CDs are also cheap to send through the mail, and make excellent mats for coffee cups when past their sell-by date.

A normal 650MB CD will hold 11 high-resolution images of 55MB size, and will also hold as much caption data as is desired—unlike a transparency, where the mount is never big enough, and the caption, on a separate sheet, invariably gets separated from its image. Using the "Contact Sheet" feature of Photoshop, you can print a page of the 11 thumbnails and their associated captions to fit into the front door of the CD box. This provides an immediately available visible record for future search purposes. Recordable DVDs have an even larger capacity than CDs.

correct one area, but have the effect of making another worse. A more flexible tool is "Selective Color," manipulating one color at a time until the desired effect is reached.

Content improvement

Cropping is the most obvious first step, to eliminate unnecessary and distracting areas. Then there are the signposts, scaffolding, garbage, and other unwanted structures intruding on the subject—these are usually not too difficult to remove using one or more of the myriad of techniques available. People are invariably in the wrong place, or don't look right, and they then need to be either eliminated, or moved to enhance the overall image.

In the pre-digital days, one of the most annoying aspects of the human presence was the abundance of garbage and plastic shopping bags that they scattered far and wide, getting into every corner of your viewfinder. Not any more. No more picking up litter in St. Peter's Square before sunrise to get a nice shot— it can now all be removed so much more easily, in the comfort of your own home, using your computer's keyboard and mouse.

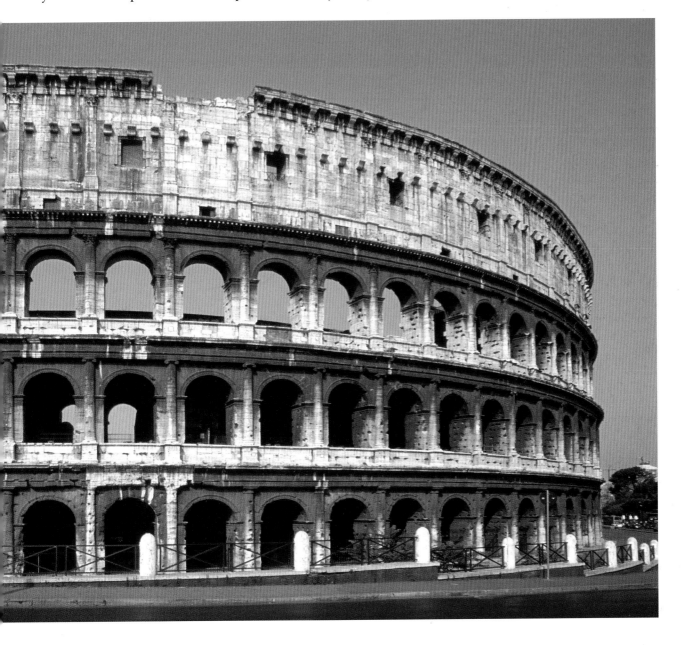

Right: Before: The sky in the top left is very bland and distracting, as is the farmhouse. A significant crop will focus the attention on the real subject, the zigzag road in Monticchiello, Tuscany, Italy. The telephone wire is catching the light and is rather annoying.

Below: After: Cropped and cleaned up. The telephone wire and other distractions have been removed, and a touch more sunshine and warmth have been added.

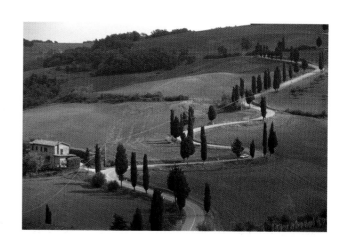

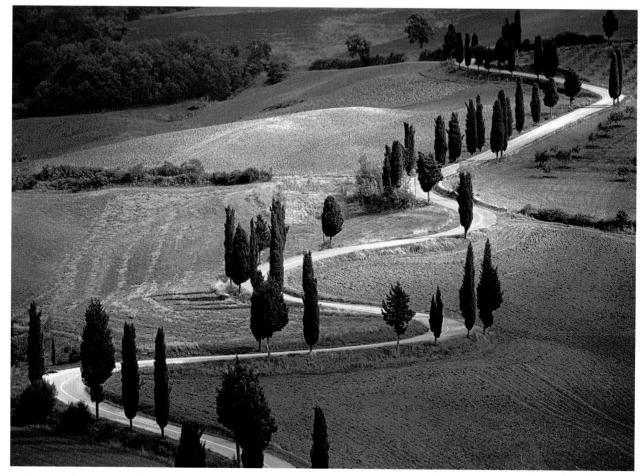

The photographer just dabbling in digital to help improve his or her sales will find that some unwanted features are much more difficult to remove than others. It is very difficult, for instance, to remove airplane vapor trails from a plain blue sky where the intensity of blue is varying in two directions. It is not impossible, but requires a high level of skill. However, the removal of minor blemishes, such as telephone wires, TV satellite dishes, and extraneous people, can usually be achieved with a moderate level of skill.

With careful manipulation, many images that were not worthy of capture before are now worth taking; and with this new tool in your photographic toolbox you can look at many subjects in a new light.

You can now take images that previously you would have thought were not worthwhile, because the people were wrong, there was too much garbage or there were ugly signs, or scaffolding. You can even shoot images in some lights you would not have considered before, because you now know that there is the possibility of

making small adjustments to rescue the situation.

Correcting converging verticals and perspective can also be achieved with a high degree of success. Correction of the pin-cushion and barrel-distortion effects that you get from using certain lenses (usually wide-angle and zoom lenses) is more difficult to achieve, but by no means impossible.

It is also worth going through your library of existing images to see which can now be made salable by the removal of unwanted features: correcting color exposure, removing a color cast, or just saturating the colors more. Some images are significantly improved by cropping out unwanted areas, and can then be made into a refreshed image for submission.

With images that claim to represent a subject or place, no matter what the "improvement," you must keep the integrity, or you may mislead.

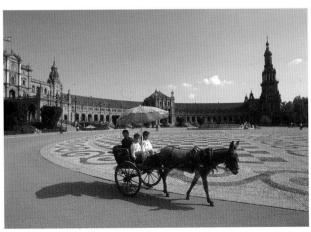

Left: Before: I felt the third child at the back of the buggy (who is also in deep shadow) detracted from the atmosphere of the image of Plaza España, Seville, Spain. In the sky above the parasol can be seen two hairs that have crept into the camera—fortunately, it is very straightforward to remove them in Photoshop.

Above: After: It was easier said than done to remove the third child. As you can see, behind the child there is a pattern of cobble stones that has to be repeated. The addition of a little more sunshine brightens the whole picture, and now the hairs have gone too.

Dealing with libraries

Finding the right library

Finding the right agency or library for your type and style of work is fundamental to the degree of success that you can expect. A library that markets predominantly lifestyle images is not going to have the same success with wildlife images. They might accept a submission of your bird photographs because they want to build up their stock in that area, but if they are marketing mainly to lifestyle customers, then the wildlife will inevitably take a back seat.

The difference between a library and an agency is that generally an agency will commission the article or feature, or is commissioned to do so, whereas the library simply provides images for someone else's story. Having said that, some large libraries still commission a very small amount of work, and the overlap between agencies and libraries is considerable.

In the US the Picture Agency Council of America (PACA) offers a website guide to picture libraries and agencies. In the UK, the British Association of Picture Libraries and Agencies (BAPLA) publishes a very informative booklet listing all their members, what each specializes in, and the essential information for making contact. This information can also be read on the Association's website. Similar associations can be found in other countries (see p. 124).

Look at your shortlisted libraries' catalogs and websites, and search the sites for all different types of image to establish their breadth of coverage, and how it relates to your own images. If you have a lot of pictures of Canada, for instance, you can get a good idea of how well this subject is covered at a particular library by using "Canada" as a search term on its website; this will also show you the quality of work they have accepted in the past.

Working with a library

Having selected three or four agencies that seem to fit your requirements and are suitable for your type of work, it is then best to contact them by letter or phone to establish how they would like to see your images, and how many they want in the first instance. Do not just send in a bunch of images without talking to them first. Many libraries have

Right: Position in my bestseller chart: #6. Number of sales: 67. Highest single sale: $1,261 (£864). Number of years since first sale: 9. My total income to date: $8,414 (£5,763). This image was such a pleasure to shoot. I saw these old ladies leave the kasbah (a North African fortress) at Ait Benhaddou, Morocco, and could not believe my luck when they came to this "bridge." Then a young girl came from this side to help them across.

Building a rapport

It is essential to build a good working relationship with each library, in order to help it to help you make more sales. The editors will understand your style of photography, and can help you to optimize the number of images accepted, and to check the quality of images taken from each of your own assignments.

When you submit your images, you want to be able to discuss the submission so you can learn what to do again, but better, and most important, what not to do—this will save a great deal of wasted film and time. The more you communicate, the more you and the library can work together to achieve the common goal of better sales.

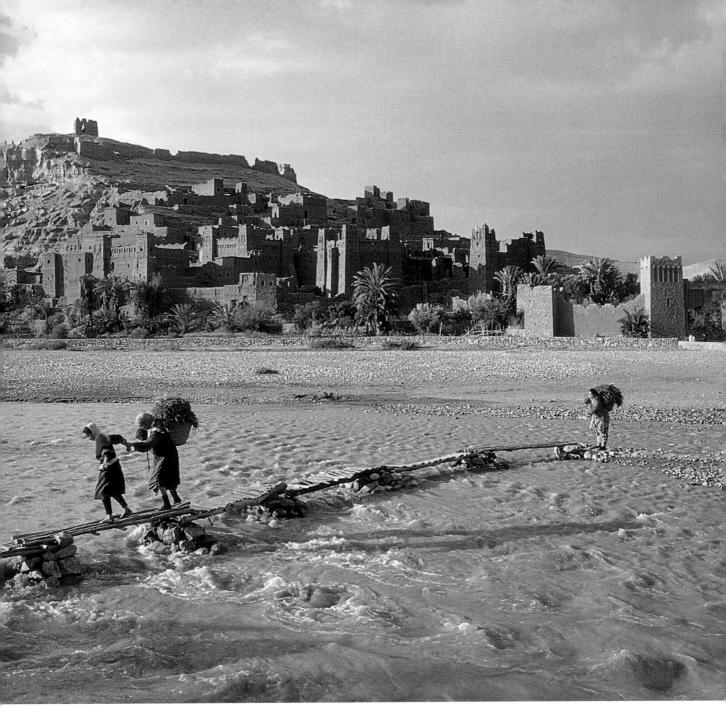

a "photographers' pack" that details all the information about first and subsequent submissions.

It is likely that a library that has international branches, or operates through a network of sub-agents, will be able to put your images in front of more potential customers than one that operates solely in one country. The more people who see each image, the greater the chance that one of them will buy it.

Most libraries now use the internet as their main catalog, and can therefore reach customers anywhere in the world. But the quality of their marketing is paramount—it is no good having thousands of wonderful images in a library using the internet if nobody knows that the library exists.

The quality of the library's website is very crucial to success. I have looked at many where the operation of the site is clumsy and the waiting is interminable—this immediately puts picture buyers off, and they will go to a site that is easier to operate. The quality of the images on the site is extremely important—it might seem a good idea to join a site where your images are the best of the bunch, but picture buyers will soon be put off using a site where they have to scroll through masses of poor quality just to find the few jewels. This is now more important than ever, because "in the old days" a picture researcher was given the task of finding images, but now the art directors and clients themselves may well scour the

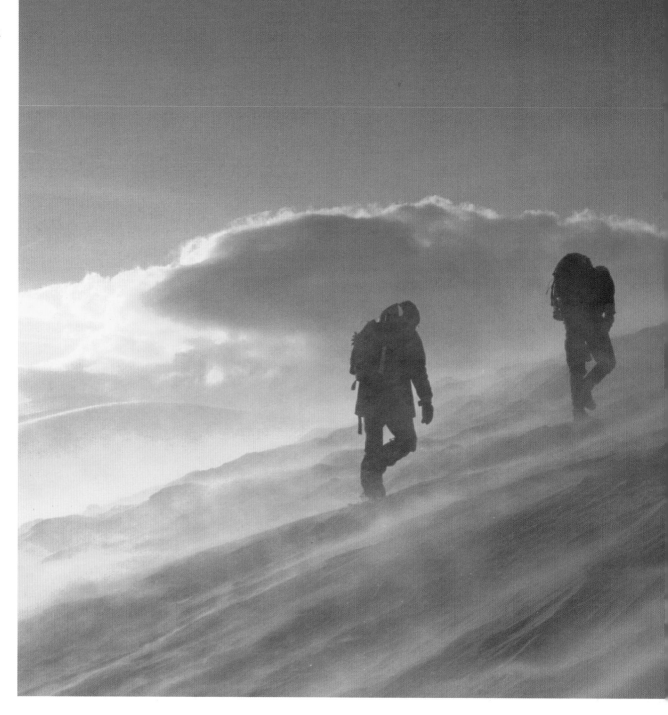

Submitting your work

Each library will have its own specifications of how it would like to receive your submissions, but in general I have found that the following methods suit most:

Transparencies

• Never send more than 200 at any one time without talking to your editor first.

• Mark each transparency with a unique identifying number.

• Put transparencies in plastic sheets with pockets, and number sheets and pockets.

• Make a separate sheet of captions that identifies each image by its location in the plastic pockets and its own identifying number.

• Make sure your name and address are on every sheet, plastic and paper.

Digital

• Create your CD or DVD of images (in Mac or PC form as the library specifies).

• Give each image a unique identifier.

• Prepare the captions relevant to each image, and list them as a separate document on the CD/DVD, using the same identifying numbers as the image.

• Make a small print (between 7x5in/ 17.5x12.5cm and 8x10in/20x25cm) of each image, and give it the same unique identifier as the image.

Naturally every library will want submissions in the manner they request, and it is really no use trying to have one rule for all. They are all so busy with submissions that if yours doesn't fit their requirements, you will lose out.

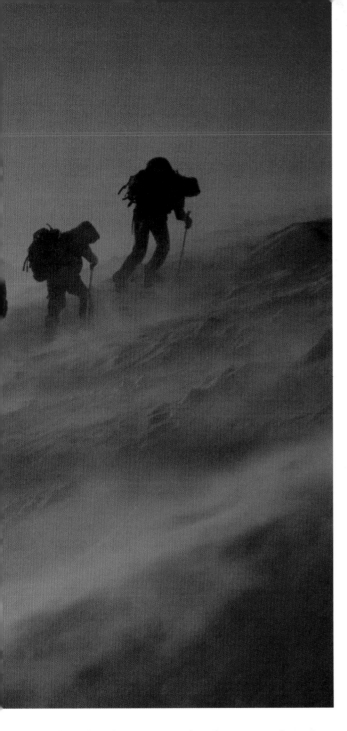

Left: Position in my bestseller chart: #7. Number of sales: 67. Highest single sale: $788 (£540). Number of years since first sale: 6. My total income to date: $8,344 (£5,715). The drama of this image is so clear to see—the weary climbers bent on achievement. Its success is no doubt due to the fact that it can illustrate so many abstract concepts, such as determination, hardship, teamwork, and togetherness. It was taken at the summit of Cairngorm, Scotland.

libraries have the volume to attract buyers, and they have the financing to do the best marketing.

In addition to traditional libraries, there are now internet-specific organizations and CD producers. Most traditional libraries use the internet, but there are companies marketing images solely through the internet in a different way. One internet company that I work with rarely edits images—they seem to put on-line everything that is submitted, so long as it meets the technical scan quality they specify. This might seem great news for photographers, because all the images they submit are available for sale. However, it means buyers have to search though thousands of mediocre images to find one good one. Will they return to a website where they know they have to waste a lot of time searching?

It is easy to put poorly scanned images on a web site, and make them available for sale. It is not easy to put professionally scanned images on a website and market that site to all the potential buyers. This is where the photographer seeking an outlet for images must study the companies operating these services very carefully, or all the hard work in capturing the image could well be undersold or wasted.

web for what they want, and as decision-makers their time is more valuable, and their patience shorter.

Last, but not least, the volume of images in the library is also extremely important because usually a picture buyer will ask for a particular image and will expect to receive several different versions, from which he or she can choose the most appropriate. The larger the library, the greater the selection they can send, but the very small library may only have a choice of one or two, or even no images at all; this will deter the buyer from returning to that library, only to have his or her time wasted. It might seem like a good idea to be a big fish in a small pond, but with libraries it is probably better to be a small fish in a big pond. Big

How much do I get?

The simple answer is, what it says in your contract—this can be vary widely from library to library, and depends on whether the sales are local or overseas.

Generally you will get 50% of local sales and 50% of overseas sales if they are made through an integral part of the same library, but if the sale is made via another associated agent, then the fee is usually reduced as yet another outfit needs a bite out of the apple.

50% sounds like a lot of money to give away, but when you consider what they have to do to achieve just one sale, then I would far rather that they did all that tiresome stuff, and let me get on with taking photographs.

Licensing

When an image is bought from a library, the buyer purchases the right to use that image in a particular way, and this is called a license. Most of the larger libraries offer traditional and royalty-free licenses. Traditional licensing can be both "exclusive" and "non-exclusive," and means that the image is licensed for a specific use only.

With an exclusive license—also called "rights-protected":
- The buyer pays a royalty to the library each time the image is used.
- There is protection against two, or more, buyers using the same image in a similar way (e.g., in the same industry or the same country).
- The buyer has exclusive use of the image under the terms of the licence; these terms may affect the use, media, print run, territory, and duration of which the image can be used by other suppliers.
- The buyer should be able to find out when and where the image has been used before—very important for high-profile advertising and product-promotion campaigns.
- Pricing is determined by the terms requested, and will be significantly higher to guarantee an exclusive license.
- Buyers generally choose to buy rights-protected licenses for high-profile projects such as product promotions, corporate identity, and advertising campaigns.

With a non-exclusive license:
- The buyer pays a royalty to the library each time the image is used, but the image is free to be used by other buyers at the same time.
- The buyer must specify the type of use (the intended use, media, geographical territory, duration, and print run) each time the image is used.
- The buyer should be able to find out when and where the image has been used before—very important for high-profile advertising and product-promotion campaigns.
- Pricing is based on intended use, media, print run, duration, and territory.

Reproduction rights
In each sale the library will endeavour to limit the reproduction rights so that future sales of that image are not stifled. The reproduction rights, therefore, will be limited to as narrow a usage as possible, to leave all other markets and territories open to that image.

The photographer wants to make sure that the library negotiates the narrowest range of rights, so that they keep the images available for all other areas. For example, if a customer in the cat-food business wants the exclusive rights to that image, we want the library to arrange for the rights to be restricted to the pet-food industry for one year, not for all advertising worldwide for the next ten years.

A royalty-free license is essentially another kind of non-exclusive license, but:
- The buyer does not have to specify intended use, media destination, duration, or territory.
- The buyer pays a one-off fee and does not have to pay royalties to the library.
- The buyer can use the image as many times as wanted without any further payments.
- The buyer will have absolutely no idea who else is using that image for what or where.
- The price is governed by the digital file size supplied.

Right: Position in my bestseller chart: #8. Number of sales: 52. Highest single sale: $817 (£560). Number of years since first sale: 8. My total income to date: $7,230 (£4,952). The sculpture of David by Michelangelo was shot on Velvia color transparency film inside the Academia Museum in Florence, Italy, using a 200mm zoom lens hand-held. In spite of the very low light level, the image is crisp and sharp. I changed it to monochrome in Photoshop so as to give it a rather older feel.

Traditional and royalty-free licensing

The traditional method of selling the use of the transparency was that the buyer paid for the use of that image for a particular and specified purpose. If, at a later date, he or she wanted to use the same image again for, say, a reprint, and this had not been foreseen or specified in the earlier sale, he or she would have to pay the fee (or royalty) again. Typically, the single-use fee for an editorial usage could be in the region of $300 (£200), of which the photographer received between 30% and 50%. All very reasonable and fair to all.

Then along came royalty-free, where the buyer pays a one-time fixed fee and can then use the image as many times as he or she likes forever and ever without the agency or the photographer getting another cent. These images are largely sold on CDs and from websites. The one-off fee the buyer pays is, say, $200 (£137), for a CD that may contain 100 images. This makes the cost to the buyer for each image very low indeed, just $2 (£1.36) each in our example (although the buyer will probably only ever use a small proportion of the images on the disk). The photographer would receive a one-off payment for the image(s) on that CD, but with the sale price per image so low,

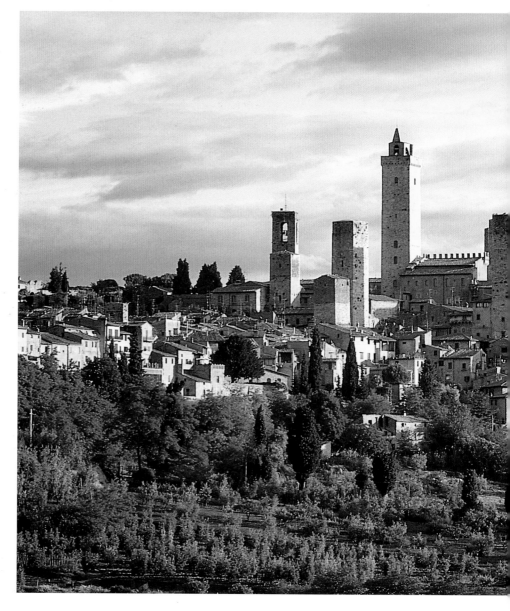

Right: Position in my bestseller chart: #9. Number of sales: 42. Number of years since first sale: 5. My total income to date: $5,943 (£4,071). This is the "classic" shot of San Gimignano in Tuscany, Italy, made stronger by the lovely light and sky. It has sold for all manner of purposes. Images of popular tourist spots always sell well, but libraries are inundated with submissions of these places—for an image to be selected by the library and then by the picture buyer, it must have that little extra "something."

the one-off fee will also be low; however, he or she will get this fee for every CD sold, and these might sell in their thousands. Typically, the photographer will receive 20% of the sale value of the CD, and if several photographers' images are included, each photographer will get a fee pro rata.

Now that we have a marketplace full of images on royalty-free CDs, why would any buyer use the far more expensive, rights-protected images from the traditional stock library? The answer is that many buyers want to know the history of the use of an image, so they can be sure that it does not conflict with what they now want to use it for. They don't

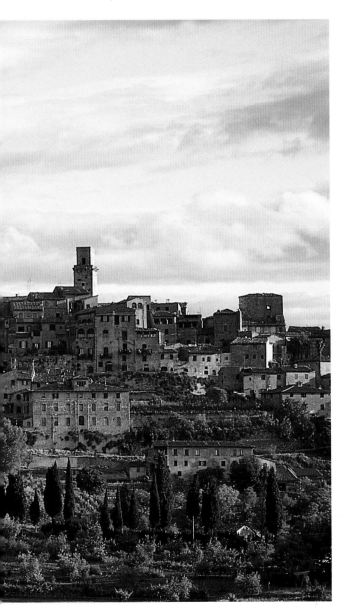

want an image that has been used extensively by one of their competitors, or one that has been associated with publicity adverse to their activities. Some buyers will want a guarantee of exclusivity especially for major advertising campaigns, calendars, and TV promotions.

The buyer of royalty-free images has to accept that many other buyers will be using the identical image, over and over again. Although this can be a disadvantage to some buyers, it may be the opposite to a segment of the market that previously was unable to use traditional stock photography because of the high fees charged, such as smaller ad agencies and specialist magazine publishers.

The royalty-free market used to have a poor name for quality, but all that has changed, and some companies now offer images of superb quality. The companies that sell royalty-free images can be divided into two groups—those who produce quality images that have been scanned at the highest resolution on drum scanners or equivalent, and those who produce lesser images for the convenience market.

Choosing the outlet

The stock photographer has to decide whether the images will sell better through the traditional rights-protected avenues, or through the royalty-free market. This choice is to some extent dependent upon the types of images he or she produces—if the images sell to trade magazines, travel brochures, websites, catalogs, and similar publications, it is likely that many of these potential buyers will now be looking for royalty-free images. The larger libraries and agencies now offer both royalty-free and rights-protected collections, so the photographer will be advised by them as to where his or her images will sell best.

The fees for royalty-free images are the same for every buyer, regardless of the use of the image, the number of copies of the publication, or the size of the printed result. The only factor that alters the price is the digital file size—the bigger the file, the more you pay. A 36MB image file might cost $200 (£137), a 12MB version might cost $100 (£68), and a 2MB image might be $50 (£34).

The fees for traditional stock sales are based on the size of the printed image, the size of the print run, where in the production the image is (a front cover costs more than an inside page), distribution, intended use, and so on.

Using multiple libraries

There are very good reasons to use more than one library. The most obvious of these is that the images not selected by your first choice library can be sent to subsequent libraries, thus maximizing the take-up of your images. Some libraries sell certain types of image better than others, so if you use multiple libraries it makes sense to divide your submissions according to the libraries' marketing prowess or specialization. The wider you can spread your images, the greater the opportunities for sales.

Right: Position in my bestseller chart: #10. Number of sales: 40. Number of years since first sale: 12. My total income to date: $5,250 (£3,596). I took rolls of images around this little harbor at Villefranche, near Nice, France, and many of them are selling really well—some almost as well as this one. When you have a good scene and light, plunder it for all it is worth. The clarity of the water gives the image a real vacation feel, and, as you have probably guessed, it has sold very well to the travel industry.

If an image is offered to a library on an exclusive basis, great care must be taken to ensure that the same image, or even a similar image, is not submitted to other libraries. A picture buyer wants to know that at that time he or she has the exclusive right to the use of that image—he or she doesn't want to see a competitor using even a similar image. Imagine if a major company was undertaking an extensive advertising campaign using one of your images, and at the same time one of their competitors also was advertising using a near-identical picture; you would not be popular! The libraries would be most unhappy with you, and might not want to continue working with you; even worse, the customers would want compensation—and the buck stops with you.

When I select an image for submission, I always clearly mark all other similar images that I am not sending, so I know that I have already submitted a version when I look at any of these pictures again. If the submitted image is not selected, then of course it can be sent to another library, but at no time can the similar images ever be sent to multiple libraries.

The process of dealing with more than one library can be confusing unless you behave in a very disciplined manner. The process I have adopted over the years is as follows:
• Divide any specific images by library specialization, and submit.
• Select general images for Library 1, and submit.
• When returns from Library 1 are received, send to Library 2.
• When returns from Library 2 are received, send to Library 3, and so on...

It therefore goes without saying that record-keeping is an extremely important facet when using more than one library. It is not just a matter of keeping track of similars, you also have to know, when submissions are returned, which of these images are now available for submission elsewhere.

This makes keeping an accurate record far from easy. Imagine you have five similars of a particular image, and you include one of them in a submission to Library 1. Other images being sent in the same

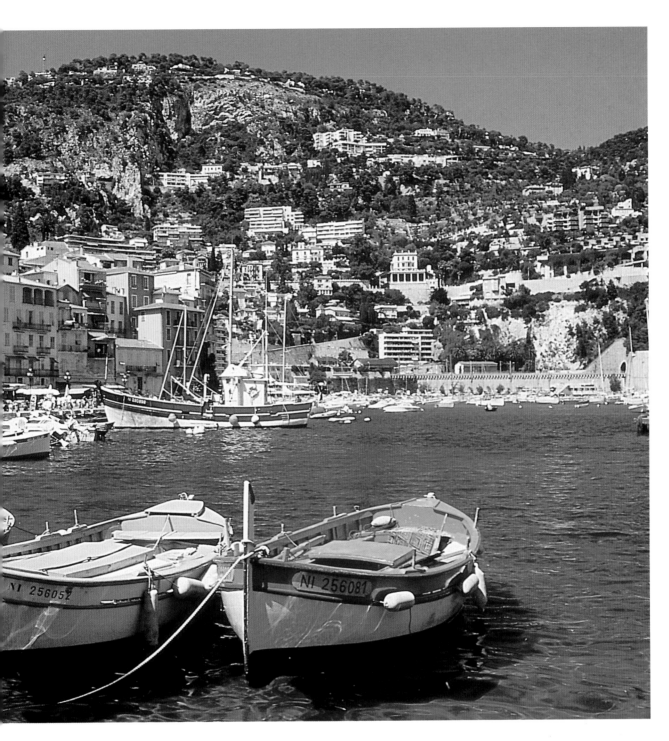

submission are sufficiently different from each other but have much the same caption, e.g. "Grand Canyon looking south from Hopi Point." This is when things get confusing—when Library 1 selects four of these Grand Canyon images, and you get the returns, how is it possible to know which ones they actually selected, so as not to send similars elsewhere? You have to make sure that all similars are marked clearly, and keep a visual record of each submission for future reference. You could use a numbering system where

numbers 4596 and 4597 represented dissimilar images—even if they were of the same subjects—while 4598a and 4598b represented similar images. A visual record could be made by laying each sheet of the submission on a lightbox and photographing it, keeping dupes of each image, or scanning each image and keeping a digital record. The latter is undoubtedly the most cost-effective method, and also gives you the opportunity to use that image for your own personal use, such as for exhibitions.

Copyright and releases

In most countries, unless the photographer is trespassing, he or she may publish photographs of anybody doing anything, so long as they not bring the person into disrepute, or ascribe to that person opinions that he or she does not hold.

Model releases

Model releases are not required for images that will be used in the editorial arena, but almost all libraries require that a properly signed model release form accompany any image that includes identifiable people if that image is to be used in the commercial or advertising marketplace. The term "identifiable people" seems to be almost any shape that could be a person, including back views and silhouettes.

However, if you do not have a model release for an image, and the library is prepared to accept it as such, it simply reduces the opportunities for sales, because some buyers in the commercial and advertising markets may not be able to use a non-released image for their specific purpose. A client may still want an image knowing that it is not model-released, and may be prepared to take the responsibility.

Copies of model-release forms can be obtained from many photographers' associations, such as the ASPP and PACA (see p. 124), or can be downloaded from certain websites (such as www.alamy.com).

Copyright

This is a topic upon which entire books have been written, so I will only summarize some of the most crucial elements as they affect a stock photographer. Many of the websites listed on p. 124 have relevant sections on copyright. Most importantly, the detail of the law can vary significantly from country to country. The law also evolves—either with new statutes being written, or by precedent being set by the courts.

Here are some very brief points about copyright and the photographer:

- The photographer holds the copyright unless he or she agrees otherwise, or assigns it elsewhere, but where the photographer is an employee, the copyright generally belongs to the employer.
- In the USA and UK, copyright lasts for the photographer's lifetime plus 70 years after death.

- A photograph with a copyright may not be copied, scanned, printed, or otherwise reproduced without the permission of the photographer. Using the image without permission is an infringement of the copyright law.
- The photographer has the right to be credited for the image.
- An artist's rendering of a photograph in another medium is a derivative use and requires permission.
- Recreating a copyrighted photograph is also a derivative use and requires permission.

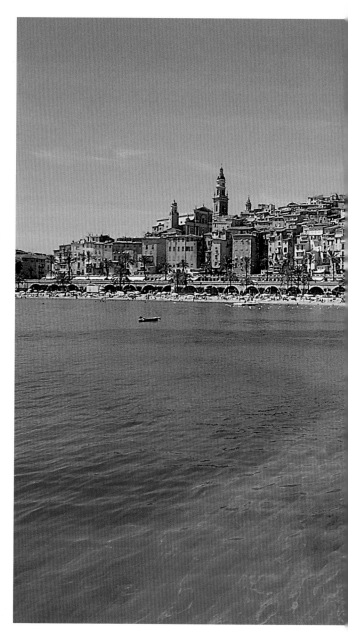

• Exceeding the terms of a license has been held to be an infringement of copyright.

Copyright law gives the photographer the right to control the manner in which the photograph is used, and the right to give licenses to others to use the image in return for the relevant fee. This licensing is where the "right" is divided into its component (and possibly more affordable) parts by selling only specific rights of use.

Images are usually licensed by the size at which they are reproduced, the prominence they have in the publication, the geographical usage, the medium of production, the time for which the license is granted, the quantity of reproductions, and whether the use is exclusive or non-exclusive.

The freelance stock photographer shooting for him- or herself holds the copyright and usually keeps it—but he or she can assign it or sell it. Copyright is not normally assigned to the library, and this means in essence that it cannot be sold without the photographer's permission.

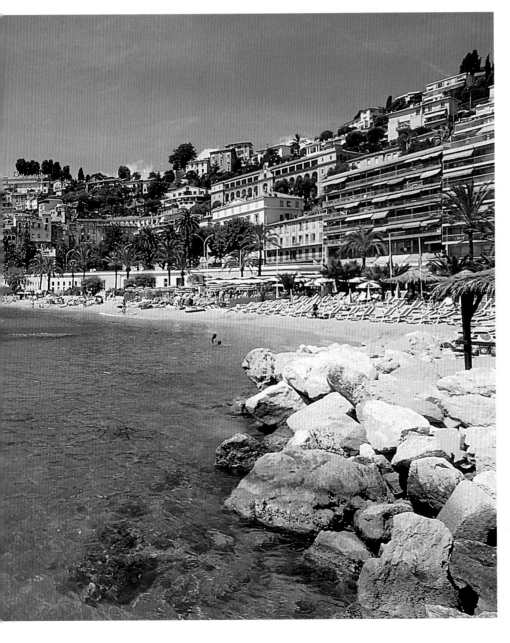

Left: Position in my bestseller chart: #11. Number of sales: 29. Number of years since first sale: 12. My total income to date: $5,250 (£3,596). There will always be a good demand for strong images of Menton, the warmest resort on the French Riviera. The success of this image comes from the clarity of the water, which entices the viewer to want to be there and to take a dip.

Useful organizations

AEAPAF

Asociación Empresarial de Agencias
de Prensa y Archivos Fotográficos
Viladomat 174
E-08015 Barcelona, Spain
Tel : +34 93-4874000
Email: aeapaf@aeapaf.org
Website: www.aeapaf.org

AoP

Association of Photographers
81 Leonard St
London EC2A 4QS
United Kingdom
Tel: +44 (0)20 7739 6669
Email: general@aophoto.co.uk
Website: www.aophoto.co.uk

ASPP

American Society of Picture
Professionals
409 S. Washington Street
Alexandria, VA
22134-3629, USA
Tel: +1 703 299 0219
Email: cathy@aspp.com
Website: www.aspp.com

BAPLA

British Associaton of Picture
Libraries and Agencies
18 Vine Hill
London EC1R 5DZ
United Kingdom
Tel: +44 (0)20 7713 1780
Email: enquiries@bapla.org.uk
Website: www.bapla.org.uk

BFP

Bureau of Freelance Photographers
Focus House, 497 Green Lanes
London N13 4BP
United Kingdom
Tel: +44 (0)20 8882 3315
Email: info@thebfp.com
Website: www.thebfp.com

BIPP

British Institute of Professional
Photography
Fox Talbot House
Amwell End, Ware
Hertfordshire SG12 9HN
United Kingdom
Tel: +44 (0)1920 464011
Email: BIPPWare@aol.com
Website: www.bipp.com

BLF

Bildleverantörernas Förening
Box 543
Sadelmakarvägen 11
S-14633 Tullinge
Sweden
Tel: +46 (0)8 55 64 53 88
Website: www.blf.se

BVPA

Bundesverband des Pressbild-
agenturen und Bildarchive e.V.
Lietzenburger Strasse 91
D-10791 Berlin
Germany
Tel: +49 (0)30 324 99 17
Email: info@bvpa.org
Website: www.bvpa.org

CEPIC

Coordination of European Picture
Agencies & Libraries
Teutonenstrasse 22
D-14129 Berlin
Germany
Tel: +49 (0)30 804 85 420
Website: www.cepic.org
E-mail: cepic@akg.de

FNAPPI

Fédération Nationale des Agences
de Presse Photos et Information
13 rue Lafayette
F-75009 Paris
France
Tel : +33 (0)1 44 92 79 23
Website: www.fnappi.com

HPA

Holland Press Agency
Postbus 13645
NL-1001 LD Amsterdam
The Netherlands
Tel: +31 20 6980810

NBBF

Norske BildeByråers Forening
Marieroveien 33
N-1390 Vollen, Norway
Tel: + 47 918 36 651
Email: knut@nbbf.no
Website: www.nbbf.no

PACA

Picture Agency Council of America
c/o Robertson/Retrofile
PO Box 301
Chatam, NY
12037, USA
Email: info@stockindustry.org
Website: www.stockindustry.org

PLANZ

Photo Library Association of New
Zealand
PO Box 136, Napier
New Zealand
Phone: +64 68351143
E-mail: planz@locationscout.co.nz

PPA

Professional Photographers of
America Inc, 229 Peachtree Street,
NE, Suite 2200
Atlanta, GA 30303
Tel: +1 404 522 8600
Email: csc@ppa.com
Website: www.ppa.com

RPS

Royal Photographic Society
The Octagon
Milsom Street
Bath BA1 1DN
United Kingdom
Tel: +44 (0)1225 462841

Email: rps@rps.org
Website: www.rps.org

SAB

Schweizerische Arbeitsgemeinschaft
der Bild-Agenturen und-Archive
Postfach 15
CH-5303 Würenlingen
Switzerland
Tel: +41 (0)56 297 3135
Email: info@sab-photo.ch
Website: www.sab-photo.ch

SBF

Svensk Bildbyråförening
c/o Tiofoto
PO Box 3252
Drottninggatan 88 C
SE-10365 Stockholm
Sweden
Tel: +46 8 24 54 10
Email: info@sbf.nu
Website: www.sbf.nu

SNAPIG

Syndicat National des Agences
Photographiques d'Illustration
Générale
10 Passage de la Main d'Or
75011 Paris, France
Tel: +33 (0)1 49 29 69 69
Email: info@snapig.com
Website: www.snapig.com

Stockphoto

Stock Photography Network
Website: www.stockphoto.net

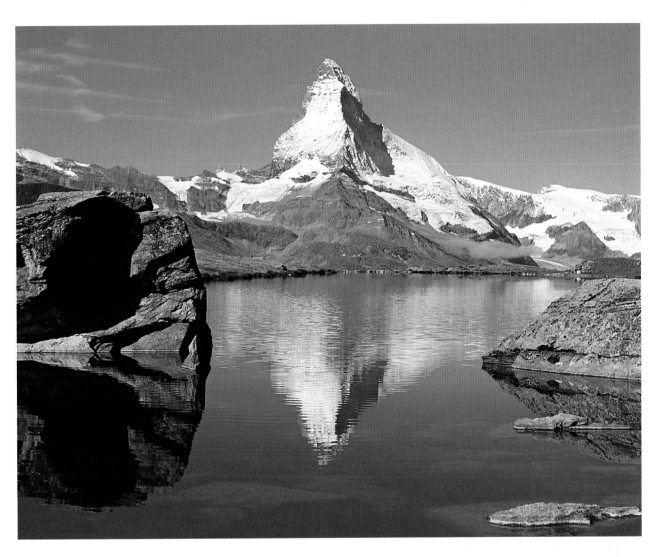

Above: Position in my bestseller chart: #12. Number of sales: 24. Number of years since first sale: 3. My total income to date: $5,045 (£3,546). Water, mountains, and reflections are excellent ingredients for a strong image. I almost didn't get this picture of the Matterhorn. We had been in Zermatt, Switzerland, a week, and had not taken any photographs because of the light. On the last morning the sun shone, and we had to do a week's worth of shooting in one day.

Index

Acknowledgements

Roger Antrobus would like to thank the people below for their valuable help.

Philip Antrobus, my cousin, for all his photographic encouragement and enthusiasm over many years.

Dig Bulmer without whom few of the moutaineering pictures could have been taken.

John Chapman for his introduction to the world of publishing.

Vanessa Kramer of Corbis for her valuable comments on library issues.

Richard West of Apple Computers for his review of my technical material.